HIDDEN
HISTORY
of the
MOHAWK
VALLEY

HIDDEN HISTORY

HISTORY

of the

MOHAWK VALLEY

*The Baseball Oracle,
the Mohawk Encampment
and More*

Bob Cudmore

Charleston | London

THE
History
PRESS

Published by The History Press
Charleston, SC 29403
www.historypress.net

Copyright © 2013 by Bob Cudmore
All rights reserved

First published 2013

Manufactured in the United States

ISBN 978.1.62619.121.1

Library of Congress CIP data applied for.

*In memory of Irv Dean—reporter, columnist and
conscientious editor*

Contents

Preface and Acknowledgements
Kitchen Table History

Many of the tales in this book could be called "kitchen table history." Stories such as the one about the baseball oracle or life in a local orphanage or how a great-uncle died in a plane crash are told to younger family members as the elders reminisce at the kitchen table.

And when somebody like me shows up to write things down, families frequently invite me to sit at the kitchen or dining room table to talk and look at old newspaper clippings and photographs.

Frances Burnham of Glenville showed me clippings about the 1928 death of her great-uncle and aviation pioneer Edward Pauley as we sat at her dining room table. His story in the book is "Death Rode on the Wings of the Wind."

Burnham had wondered whether her great uncle would have wanted the story told. She asked her long-deceased relative to make her Christmas cactus bud if he wanted the story published in Bob Cudmore's new book. The cactus had been passed down through four generations of Burnham's family.

After several requests, either the spirit of the aviator or the force of nature complied. The cactus produced a flower. More flowers popped out in following days. Burnham said, "Doggone it. He did it."

Thanks to all the people who let me in on their family secrets for the new book, with or without the blessing of ancestral ghosts. Thanks also to the people who purchased more than 1,300 copies so far of my first History Press book, *Stories from the Mohawk Valley*.

The new book, *Hidden History of the Mohawk Valley*, takes you back to forgotten people and places: a sailor who cheated death when he went down with a stricken submarine; Camp Agaming in the Adirondacks, where a young Kirk Douglas was a counselor; and the 1957 Mohawk Indian encampment on the Schoharie Creek, visited by American man of letters Edmund Wilson.

The book also includes anthropologist John Collier's compelling photos chronicling life along the Mohawk River two months before America entered World War II.

ACKNOWLEDGEMENTS

Thanks to the late Irv Dean of the *Daily Gazette*. Irv edited my *Gazette* columns for more than twelve years, and his encouragement and suggestions meant a great deal to me. Thank you to John Cropley, who now has the task of preparing my columns for publication in the newspaper.

Audrey Sears provided much help as this book was being written, frequently suggesting questions that readers would want to know.

Jerry Snyder, president of Historic Amsterdam League, provided essential assistance in compiling photographs. Contemporary photos for the book were taken by Gerald Skrocki. Amsterdam city historian Robert von Hasseln and Bookhound proprietor and *Upstream* editor Dan Weaver were also helpful. Thanks to Montgomery County historian Kelly Farquhar, former Fulton County historian Peter Betz, former Montgomery County historian Jacqueline Murphy, Amsterdam World War II historian Robert N. Going, Alessa Wylie of Old Fort Johnson, Ann Peconie of the Walter Elwood Museum and many more.

A special tip of the cap to Old Peddler's Wagon proprietors Ed DiScenza and Ellen Benanto in Amsterdam for their retail support of my books.

HUGH DONLON AND JOHN DONLON

Although I never met him, I owe a great debt to *Recorder* reporter and historian Hugh Donlon. His book *Annals of a Mill Town* on Amsterdam, New York history is frequently quoted in these pages.

From a Mohawk Carpet publication, the *Mohawk Courier*, April 1925. The hills in the town of Florida provide impressive views of the Mohawk Valley. *Tom Pikul.*

"Should personal credentials for assuming appraisal responsibilities be required or even be of interest, it may be cited that few Amsterdamians of today have lived here longer and have been closer to mainstream activities," Hugh Donlon wrote in his book. Donlon was born in 1896. He retired from the *Recorder* in 1971, his history book was published in 1980 and he died at age ninety-three in 1989.

He continued, "Decades of newswriting, largely about government at city and county levels, included nearly 15 years of gossip mongering through

the 'Main Street' column, a daily literary grind that at times was about as painful to the columnist as to townspeople 'roasted' in caricature. There are easier ways of earning a living, but none better than reporting in getting to know people."

It has been a pleasure over the last several years exchanging e-mails with Hugh Donlon's son John Donlon. According to a childhood friend, John Donlon sang tenor in a barbershop-style singing group that could be heard "in occasionally raffish song" under Guy Park Avenue's streetlights. He graduated from the U.S. Naval Academy in 1949 and became a nuclear submariner. He commanded the USS *Shark* in 1963 and later the USS *Woodrow Wilson*. Today he lives in Connecticut.

He and his wife and family moved twenty-six times during his navy career, living up to a family rule, "Never fail to stay together (kids and all) on home plate (wherever it might be) unless expressly forbidden by direct order of competent authority." Good rule!

PART I
People We Remember

Chapter 1

The Weather Prophet

C ousin George Henry Casabonne was a stonemason, farmer and factory
worker who was famous for his long-range Mohawk Valley weather
forecasts. Born in Northville in 1886, Cousin George used lunar phases,
the size and prevalence of woolly bear caterpillars and his own weather
records when he created his seasonal forecasts. Casabonne said he based his
predictions on the "sign of the moon like the Indians did."

Historian Hugh Donlon wrote,
"Like Houdini and other professional
escapists, weather prophets always
had a way of getting out of tight
places."

Cousin George believed that
weather conditions had never been
quite the same since calendar makers
crowded thirteen lunar phases into
twelve months. He maintained that
"satellites and Sputniks" zooming
through space led to wind currents
and rain here below.

Weather prophet Cousin George Casabonne
with fiddle and tulip. *Barbara Pawlowski.*

Casabonne burst onto the local media scene in the 1930s after the death of a weather prognosticator called Uncle George Van Derveer of the town of Florida. For many years, Cousin George drove a beat-up 1922 pickup truck to the newspaper to deliver his forecasts.

Cousin George became the darling of the regional newspaper and radio media and lived long enough to be featured on WRGB television. He was in demand as a fiddler and caller at square dances, although he took some ribbing because of the squeaky sound of his violin.

Donlon wrote, "One afternoon during an impromptu recital at the *Recorder* news room he happened to mention that the violin maker has selected his wood from a well-seasoned barn door."

A critic queried, "How come the maker didn't take out the door squeaks first?"

Cousin George serenaded downtown Amsterdam shoppers with his fiddle and appeared as Santa Claus at Christmas parties. He played the harmonica and the Jew's harp and could clog dance and tap dance. As a showstopper, he would sometimes do a high kick.

Presidential historian David Pietrusza recalled that Casabonne was a regular at A. Lenczewski's Bar and Grill at the corner of Reid and Church Streets. Pietrusza grew up in an apartment over the bar.

As a stonecutter, Cousin George worked with his father, Germaine, in the early years of the twentieth century. Cousin George was said to have used stone from the Erie Canal in Fort Hunter for the Montgomery County Courthouse in Fonda. He dowsed for water using a divining rod.

He was married to Lydia Kruger, and the couple had four children. Starting in 1917, the family maintained a farm and home on West Line Road in the town of Charlton in Saratoga County. The home is still in the family.

He worked at General Electric in Schenectady until 1951, driving a battery-operated forklift. For many years he had a dog named Tootie. Toward the end of his life, he moved to his daughter Georgianna Chirickio's home on Lyon Street in Amsterdam.

Former reporter Steve Talbott's desk at the *Amsterdam Recorder* was closest to the door in the 1970s. Talbott tended to receive incoming visitors first, including the annual fall visit from Cousin George with his winter forecast.

Talbott said, "Stan Silvernail, the managing editor, a great guy and good editor, was the keeper of the Cousin George memory file. He would tell us young reporters about how Cousin George would admit to his occasional mistaken forecasts. There was a picture in the files of Cousin George shoveling shoulder-high snow in the *Recorder* parking lot on a day when he had said there would be no snow."

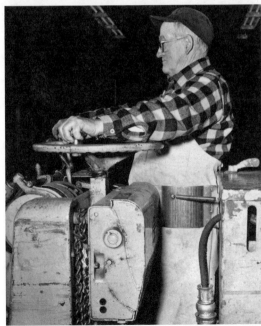

Top: Cousin George with wife, Lydia. *Barbara Pawlowski.*

Bottom: Cousin George driving a GE battery truck. *Barbara Pawlowski.*

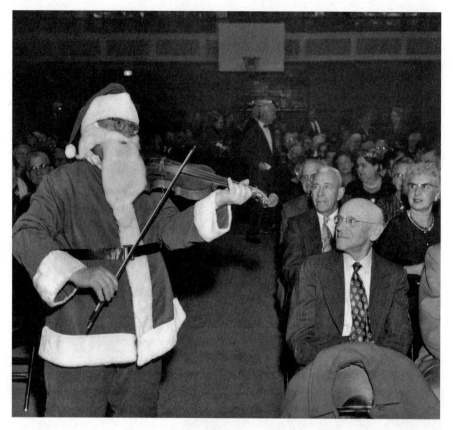

Cousin George as Santa amuses and bemuses a Schenectady GE crowd. *Barbara Pawlowski.*

In fall 1973, Cousin George's granddaughter (now Barbara Pawlowski) drove him to the paper. When Talbott asked about her grandfather's health, she looked down sadly and said he was not well.

On March 16, 1974, Cousin George sent his granddaughter to the *Recorder* with his spring forecast the day before he was admitted to Amsterdam Memorial Hospital.

The newspaper reported, "Cousin George's last forecast was among his best, and right on the button." That phrase was one of his favorites. He died March 21, 1974, the first day of spring. Snow turned to rain as he had predicted. A member of St. Mary's Church, he was buried at the parish cemetery in Fort Johnson.

The *Recorder* wrote, "Wherever there was to be fun and activity, Cousin George was likely to turn up."

Chapter 2

The Life and Times of "Dixie" Veal

An African American slave who joined up with New York State troops marching through Georgia in the Civil War was eulogized when he died for having become one of the best-known citizens of Amsterdam.

When General William Tecumseh Sherman's Union army was in Georgia, young Anthony "Dixie" Veal fled the plantation where his family lived at Spring Mountain near Atlanta and joined the 134th New York Volunteers. Veal's last name was that of the owners of the plantation where he was born. In the Union army, Veal became a servant for Captain Perry McMaster of Middleburgh.

When the war ended, Veal went to Middleburgh with McMaster. Veal worked as a porter in Central Bridge for nine years, handling baggage at a local hotel. He then moved to the Hotel St. Augustan in Cobleskill owned by Morgan D. Lewis and was a porter at that hotel for another nine years.

When the Warner Hotel was built at East Main and Walnut Streets in Amsterdam in 1881, Lewis became the proprietor, and Veal began a twenty-year career as porter there.

In 1882, Veal married Lavina Hunter of Central Bridge. They had one daughter and lived near the Warner at 15 Walnut Street.

A Formidable Man

Veal became such a well-known local character that an Amsterdam politician once wrote a song lampooning Veal that was going to be performed on the stage of the Opera House located in the Warner Hotel.

According to a 1909 *Recorder* story remembering the incident, Opera House manager Andrew Neff invited Veal to hear the song-and-dance man rehearse the routine. The piece began, "My name is Dixie Veal and I'm limber as an eel, the runner and the bouncer at the Warner." There was a lot of Negro dialect and exaggerated dance moves.

Although Neff loved the piece, Veal was livid, according to the newspaper, "With his head down and his shoulders up and his eyes like the two horns of a bull, he was slowly making for the actor."

Veal told the man the city's black community would be outraged if the performance took place. The Dixie Veal number did not make it to the stage.

The Opera House had once featured a showing of *Uncle Tom's Cabin*, including a street parade with real bloodhounds. John Philip Sousa's band played the house, as did presidential candidate William Jennings Bryan and boxer John L. Sullivan.

Historian Hugh Donlon wrote that Opera House patrons sometimes loaded up on discarded vegetables at O'Neil's Grocery across the street, hurling rotten tomatoes at the stage if they didn't like a show. Donlon wrote that the hard-to-please playgoers in Amsterdam made the city a prime spot to try out Broadway shows.

Hard Times

Veal's mental and physical health began to decline in the spring of 1903. November 3 of that year he was forced to give up his job because of his illness. His mental derangement grew to such an alarming extent that on January 23, 1904, he was sent away to the state mental hospital in Utica. He died in Utica that April 6 at age sixty-two and was buried in Central Bridge.

When Veal died, the *Recorder* wrote, "Few people in Amsterdam were better known than he, and for years he had been considered the leader of his race in this section, being prominent in the affairs of St. Paul's A.M.E. Zion church, a liberal contributor to its welfare and people, and a leader in all colored social events."

Veal had showed the newspaper a letter received in 1903 from the current proprietor of the former plantation where he was born. The letter had an update on Veal's brothers and sisters and said descendants of the original plantation owner were involved in several pursuits including a granite quarry. Veal said he wanted to go back to Georgia for a visit and "grasp the hands of the family members whose name he bore" and inform them of the prosperous life he was living in Amsterdam.

Veal was presumed to have laid away a great deal of money during his many years at the Warner. He sometimes earned as much as ten dollars per day, a large sum at that time, and lived modestly. However, when Veal died, his wife did not know what had become of her husband's savings or money realized from farmland Veal had sold in Central Bridge. There was speculation that Veal had a secret hiding place. If there was such a hiding place, its location was lost when Veal died.

The *Recorder* wrote, "Throughout the state no hotel attaché was better known, and even now inquiries are daily made at the Warner and the (New York) Central passenger station as to the welfare of the veteran porter who so long and so carefully looked after the baggage of the Warner's patrons until he seemingly became as much a fixture as any department of the hotel."

Amsterdam Hotels

Amsterdam's *Morning Sentinel* newspaper in 1896 described the Warner Hotel as a handsome brick-and-stone structure. There were seventy-nine rooms, and the dining room could seat one hundred people. The cuisine was said to equal any two-dollar hotel in the state.

The Warner had its own electric generator and an "electric annunciator," described as a way to connect hotel rooms to a telephone switchboard. The hotel boasted a billiard room and a bar stocked with wine, liquor and cigars. It had three large sample rooms so commercial travelers could display their wares.

A fourth floor was added to the Warner in 1902, and its name was changed to the Amsterdam Hotel in the 1930s. Before demolition in the 1970s, the building was the location of Lurie's Department Store.

The Barnes Hotel on Market Street replaced another hotel at that location in 1910 and prospered for many years. The building was renovated and reopened as the Peter Schuyler in 1948. The Peter Schuyler closed within five years.

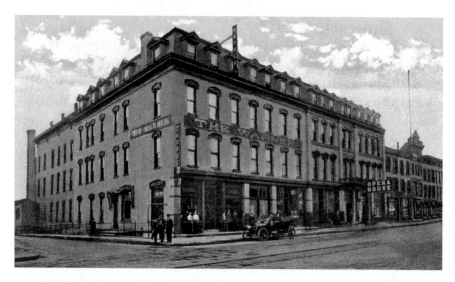

The Hotel Warner at East Main and Walnut Streets in Amsterdam. The hotel's best-known porter "Dixie" Veal lived on Walnut Street. *Gerald Snyder.*

There were residential hotels on Division Street, the Burlington built in 1917 and Hotel Thayer, dating from 1924. The name of the Thayer changed frequently; over time it became the Ancon, Montgomery, Earle and Hotel James.

Chapter 3

The Baseball Oracle

A man living in Rome, New York, correctly predicted the outcome of twenty-one St. Louis Cardinals baseball games at the end of the 1930 season.

According to his son, James J. Sheridan III of Amsterdam, James J. Sheridan II was operating a store called the Smoke Shop in Rome when he began sending uncannily accurate telegrams to the manager of the St. Louis Cardinals, Charles "Gabby" Street. The messages predicted the outcome of pending games and often gave Street instruction on who should pitch.

According to a 1930 column by Harry T. Brundidge in the St. Louis Star about "this fellow Sheridan in Rome, N.Y.," the first telegram came September 9 when the Cardinals were in fourth place, "Do not worry, you will lose today, regardless of your pitching choice; you will win the next three."

That day the Cardinals lost to the New York Giants before winning the next three games. The following day, another message promised, "Everything O.K. You will win two and lose one."

Street read the prediction to the team. "Say," he exclaimed, "it's from the same nut who sent me the telegram in New York." But the Cardinals performed as the "nut" predicted.

The telegrams continued, and on the final weekend of the season, St. Louis hosted Pittsburgh for a four-game series. Street received a telegram stating, "Have no worries. Pitch [Burleigh] Grimes and [Jesse] Haines in first two games and Cards are in the bag. The pennant will be clinched Friday so you can have some rest."

St. Louis Cardinals manager "Gabby" Street received messages in the 1930 season from baseball oracle James Sheridan. *National Baseball Hall of Fame Library, Cooperstown, New York.*

Grimes pitched a shutout. Haines helped clinch the pennant the next night as St. Louis won again.

The Cards moved into the World Series against the Philadelphia Athletics. A telegram from Sheridan said Sylvester Johnson should pitch. He warned Street that St. Louis would lose two in a row if Grimes pitched that day. Street ignored his oracle, put Grimes on the mound and St. Louis lost two games.

The next telegram from Sheridan in Rome said, "Don't worry. I'm praying. [Bill] Hallahan and Haines will win Saturday and Sunday. I'll wire you about Monday's game." Hallahan and Haines won their two games.

The Monday telegram failed to arrive. Team members were reportedly unsettled by their loss of direction from Sheridan and lost Monday's game.

A final telegram arrived before game six: "Hallahan and Haines will win the championship for St. Louis tomorrow and Thursday." For the first time, Sheridan was wrong. Philadelphia defeated St. Louis by a score of seven to one and won the World Series.

A WELL-LIKED MAN

Sheridan left Rome in 1931 and lived in other valley municipalities such as Herkimer. In late 1934, the family moved to Stewart Street in Amsterdam. Overwhelmed when he lost his job as a cigar salesman, Sheridan sent a goodbye note to a friend, a reporter at the *Rome Sentinel*. The concerned reporter in Rome contacted the *Recorder* newsroom in Amsterdam, and their reporters went to Sheridan's house; the forty-two-year-old already had hanged himself.

The *Sentinel* wrote in an editor's note following Sheridan's death, "This fellow Sheridan of Rome, N.Y. was one of the best-liked men ever to live in this city. Although beset by financial difficulties, he seldom lost his smile for his friends, his spirit of good fellowship. Many Romans knew and liked Jimmie Sheridan."

James Sheridan III said his mother, Ursula, and two sisters briefly went on welfare, but his mother soon found work in finance. Ursula Sheridan became well known for operating a successful finance company on Chuctanunda Street in Amsterdam.

Chapter 4

Descended from Adam

According to one of his grandsons, Adam Betz had a knack for subduing people without damaging them. Peter Betz, professor emeritus at Fulton-Montgomery Community College and former Fulton County historian, said of his extended family, "We are all descended from Adam."

Born in Weinheim, Germany, in 1870, Adam Betz came to America in 1891. He ran away from his home in Germany, partly because he did not want to be conscripted into the army. Also, he was convinced by handbills that told how wonderful life in America would be.

Peter Betz said, "He climbed out the window with the bed sheets tied together and never saw his parents again."

Adam settled first in Rome, New York, which had a large German population. He married his wife, Elise, within six months and moved to Amsterdam to ply his trade as a barber at 6 Market Street. Adam was a barber like his father but also had received martial arts training in preparation for a police job.

Peter Betz said, "He was going to work one day, and there was a very obnoxious drunk on the street causing trouble, and Adam apparently subdued him without any weaponry, and that came to the attention of the sheriff."

In the early 1900s, the barber began serving as an Amsterdam constable, later as Children's Court officer and, for forty-six years, he was a court officer in Fonda and deputy sheriff.

Author Harvey Chalmers wrote a story about Adam called "Law Enforcement in the Age of Homespun." The sheriff asked for Adam's help

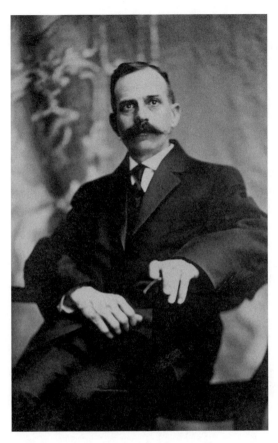

Adam Betz, barber and Montgomery County law enforcer. *Peter Betz.*

in subduing a farmer armed with a shotgun in Stone Arabia who was keeping authorities at bay on the front porch of his home.

Arriving on the scene, Adam noticed that the deputies could see the back door of the house through the open door on the front porch. Adam snuck to the rear of the house, and when the deputies saw Adam, they created a commotion out front, enabling Adam to sneak up on the farmer and knock him out with a blackjack.

"There's your man, sheriff," Adam observed. "You'll find his wife's body inside."

Chalmers wrote that Adam drove off in his horse-drawn carriage and waited until he had gone several miles before lighting his pipe, "Then to his annoyance and surprise, his hands shook so that he burned off one side of his prized mustache."

"Adam was a great one with a blackjack," Peter Betz said. "He was not one to use a pistol, and I don't know if he ever had to."

One of the few times Adam was hurt, he was repossessing chickens. While be bent down to get the chickens, a woman hit him with a block of wood, dislocating his shoulder.

Adam and Elise had four children: Elizabeth, George, David and Peter's father, Paul. George worked with his father as a barber. George's son was John Betz, who founded the Betz Funeral Home in Amsterdam.

Adam's wife, Elise, died in 1932, and two years later, Adam and his daughter visited Germany. Peter Betz said that George's son John was still

in high school when their grandmother died, and the funeral helped steer John in the direction of a career as a mortician. In 1945, George relocated the family barbershop to the old First National Bank Building on East Main Street.

Peter Betz said that as an immigrant himself, Adam was sympathetic to honest immigrants and concerned with their rights, "When I was small, he was in decline, and I saw him frequently, but I didn't really know what to say to him. And then when he died, we had the funeral and it was about the biggest funeral I've ever attended in my life. And there were all these people standing around telling my older relatives that Adam did this for them and Adam did that for them. And I began to get a much greater appreciation for the man."

Adam Betz died in June 1951. The *Recorder* editorialized, "His was very frequently a grim sort of business, yet he never lost a native sense of humor, and many a man involved in the toils of the law benefited through following his sage advice."

Chapter 5

The Anthropological Photographer

John Collier Jr. documented the waterfront and downtown Amsterdam during a photo shoot for the U.S. government on October 15, 1941. His pictures captured the spirit of hardworking, scrappy Mohawk Valley residents battered by the Great Depression and about to be thrust into war.

Collier was born in 1913 in Sparkill, New York, in Rockland County. His father, John Collier Sr., was an advocate for the rights of Native Americans who served as U.S. Commissioner of Indian Affairs during Franklin D. Roosevelt's administration from 1933 to 1945.

Injured in an auto accident at age eight, John Collier Jr. had learning disabilities. Having trouble in school, he was apprenticed to a painter whose wife was a photographer. In the 1930s, Collier established a home in New Mexico.

John Collier, the anthropological photographer. *University of New Mexico.*

Top: A woman walks down Chuctanunda Street toward East Main, past the Textile Workers Union of America, which represented Amsterdam carpet mill workers. *Library of Congress.*

Bottom: Young man at an Amsterdam vegetable stand. *Library of Congress.*

From 1941 to 1943, Collier was a traveling photographer for the federal government's Farm Securities Administration and Office of War Information under Roy Stryker. Stryker, a charismatic bureaucrat, hired Collier and others to document day-to-day American life with a focus on civil defense and public morale. Stryker made sure that his photographers were well briefed and properly funded before they were sent out.

When the federal project ended, Collier went on to use photography as a tool in anthropology, the study of human cultures, working with Cornell University and other institutions. He later became a professor at San Francisco State University. He died in 1992 in Costa Rica.

Thousands of Collier's 1940s photos are archived at the Maxwell Museum of Anthropology at the University of New Mexico in Albuquerque. The photos used in this book were secured from the Library of Congress.

Lock 11

Collier was familiar with boats. As a young man he was a seaman on a sailing ship on an ocean voyage from San Francisco to Dublin and toward the end of World War II served in the U.S. merchant marine.

In Amsterdam, Collier took pictures of barge and boat traffic at Lock 11 on the Mohawk River/Erie Canal, adjacent to a colonial home, Guy Park Manor. In 2011, Tropical Storm Irene badly damaged the area around Lock 11, including Guy Park Manor, which then housed the city's history repository, the Walter Elwood Museum.

The Mohawk River/Erie Canal is also known as the Barge Canal. Few barges are seen today, but in 1941, barges and self-propelled freighters were plentiful and pleasure craft were much fewer in number than today.

Collier documented the passage of an oil tanker, the *Providence Socony*, and a trio of wooden barges, pulled by a tugboat through Lock 11. He also took a picture of what he called a yacht, by standards of today a rather modest boat called *Gypsy*.

The river was terribly polluted by industrial waste and sewage in 1941. Downstream of Lock 11, Amsterdam added its share of industrial waste from the North Chuctanunda Creek, which carried carpet dye from city factories into the river.

A local resident told anthropologist Susan Dauria, who studied Amsterdam in the 1990s for her doctoral dissertation, that the creek in winter used to look

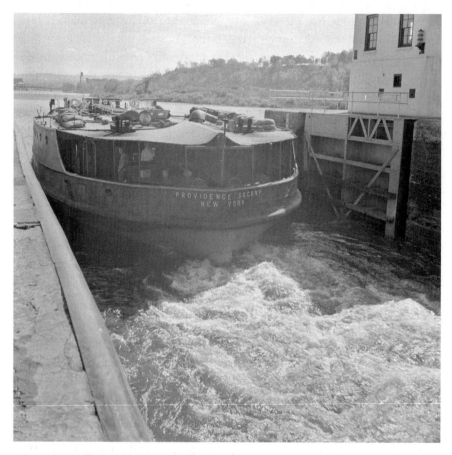

Oil tanker *Providence Socony* leaves Amsterdam Lock 11 on the Erie/Barge Canal. *Library of Congress.*

Opposite, top: Barge *Edward Hedger*, made of wood, in Amsterdam Lock 11. *Library of Congress.*

Opposite, bottom: A tugboat pulling several wooden barges out of Amsterdam's Erie/Barge Canal Lock 11. *Library of Congress.*

The pleasure boat *Gypsy* in 1941 in the Erie/Barge Canal Lock 11. Pleasure boats dominate Mohawk River traffic today. *Library of Congress.*

like spumoni ice cream, frozen in layers of color. The smell was offensive, especially where the creek passed through downtown under the Grove Street Bridge. Unlike today, the river was not seen as an aesthetic asset. People of means moved their houses up the hill to get away from it.

LITTLE HOUSE BY THE RIVER

There used to be a small house near where the North Chuctanunda Creek enters the Mohawk River in Amsterdam. The men who lived in

the small house rented boats and hosted card games. Decades ago, you could see the dwelling from the road that ran down a hill from the former Bridge Street overpass to the now demolished passenger train station. There was even a jury-rigged connection from the house to the electric power grid.

As teenagers, Amsterdam native Frank Raco and his friend, the late Bill Joyce, used to rent boats from a man who lived in the little house. Raco said he and Joyce, dressed in sport coats and ties, would skip church on a Sunday morning and rent a rowboat at the little house for a jaunt on the river. Sometimes they would take the boat through the culvert under Main Street to go as far as they could up the North Chuctanunda Creek.

The man who lived at the house advised his teenage customers to stay away on Friday nights. Raco said the little house hosted big card games on Friday nights, presumably below the line of sight of local authorities.

Pete Marcucia of Amsterdam wrote that he too remembers what he called the shanty by the river and remembers two men living there. Marcucia said, "This building was made of used, weathered lumber and was the size of a good-sized one car garage, probably fifteen by twenty feet with a large front deck or porch that faced the river.

"The time period was the mid-1950s, and the inhabitants were said to be 'Sailor' Gorman and 'New Yorker,' two colorful characters of the time. They didn't bother anyone, which is probably why the authorities turned a blind eye on the structure."

DOWNTOWN

Collier took many of his 1941 pictures in downtown Amsterdam. If you are a certain age and a native of a city like Amsterdam, the memory of the old downtown has a place in your heart. Downtown was where you shopped, met your friends and let the hustle and bustle banish loneliness. Downtown is a touchstone to your memories. Collier's images provide us with a fleeting glimpse of the downtown we remember, even if the details are less ideal than we recall.

In one of Collier's photos, three older women are talking near the long gone S.S. Kresge five-and-ten-cent store on East Main. A younger woman is to the side looking in her open purse. All are wearing hats and coats. A man passing by has a fedora on his head, but his shirtsleeves are partly

Women talking on the south side of East Main Street in Amsterdam, near S.S. Kresge. *Library of Congress.*

Opposite, top: Two men talking and watching in Amsterdam's downtown. *Library of Congress.*

Opposite, bottom: John Collier called this 1941 picture "After School." The two young men with bowling ball bags are from Gloversville. The teens are on East Main near Railroad Street. *Library of Congress.*

rolled up. His head is down. There are parking meters and flags on the street. No one is smiling. Perhaps the three women are sharing bad news. The flags on the street are from the recent Columbus Day parade.

Two older men face each other in front of a store window in another photo. They wear fedoras and rumpled sport coats. The man facing us uses a cane and wears a sweater. His shoes are scuffed. The other man gazes suspiciously down the street.

After School

In a picture Collier captioned "After School," three young men and a young woman are talking. Like their elders, they are not smiling. The young woman is wearing saddle shoes and bobby sox. One youth wears a sweater with a "G", apparently for Gloversville High School. He and a young man in a leather jacket carry bowling balls.

Family members identify the man in the leather jacket as Albert Basileo, whose Gloversville bowling prowess was covered by the *Leader Herald* that year. Born in 1923, Basileo and four of his brothers served in World War II. Albert became a seaman first class who crossed the Atlantic Ocean early in 1945. He died in 1997. The young man wearing the Gloversville sweater is James "Jimmy" Musella.

Sports have always been important in the Mohawk Valley. In October 1941, the Bigelow Weavers soccer team from Amsterdam was hosting a top team of Italian American soccer players from New York City. The local paper that October profiled Butch Milnyczyk, a lineman for the semipro football team the Amsterdam Zephyrs.

Another photo from the 1941 Collier shoot shows that Kresge's is celebrating Down on the Farm Week with apple pie for a quarter. Many people frequented Kresge's downtown lunch counter years ago, including my frugal grandmother, despite the fact that the gravy on the turkey dinners at Kresge's was a color not found in nature.

Opposite, top: Kresge's five-and-ten-cent store is observing Down on the Farm Week. *Library of Congress.*

Opposite, bottom: Amsterdam's Holzheimer & Shaul store is celebrating Choose Your Coat Week. *Library of Congress.*

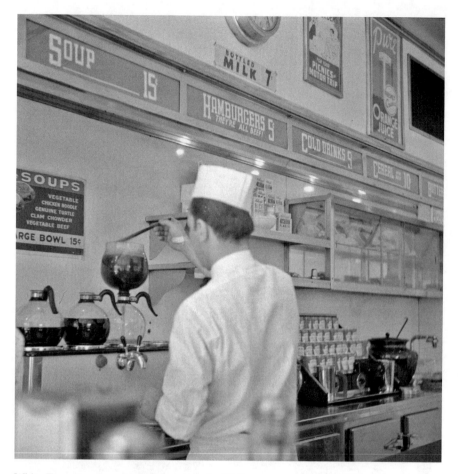

White Tower hamburgers looks modern for 1941 as a counterman makes coffee. *Library of Congress.*

Opposite, top: It's after 1:30 p.m., according to the clock, and the White Tower counter is not very crowded. *Library of Congress.*

Opposite, bottom: The White Tower is at Church and East Main Streets. In the background, an Amsterdam newsstand is visible. *Library of Congress.*

Holzheimer and Shaul's department store was having a coat sale that October and advertised it in the newspapers and their store window. "Choose your coat week" promised fur-trimmed coats starting at $29.95.

The modernistic White Tower hamburger restaurant was on the north side of East Main at the intersection with Church Street. Inside, an employee

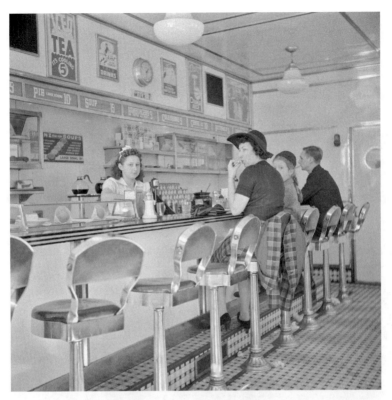

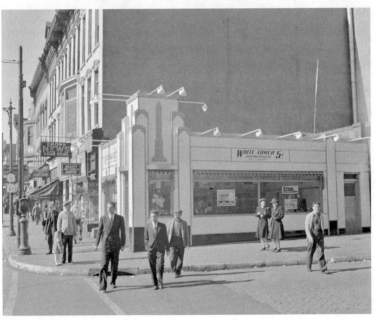

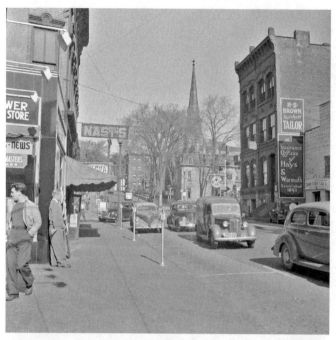

Top: Looking north on Church Street, the Second Presbyterian Church is in the distance. The church was destroyed in a fire in 2000. *Library of Congress.*

Bottom: Uniforms are displayed in this Amsterdam store window. *Library of Congress.*

Opposite: Two men dress the window at the Montgomery Ward's store in Amsterdam. *Library of Congress.*

makes a new pot of coffee under a sign advertising soup for fifteen cents. Hamburgers were ten cents but appeared to be on sale for nine cents. It's a little after 1:30 p.m. and three customers are having lunch as a waitress looks warily at the camera from behind the counter.

In a Collier picture that has been published frequently, two men in suits join two other men less formally attired in crossing Church Street in front of the White Tower. Local boxer "Pinky" Palmer owned the Crown Cigar and News on East Main, also visible in the shot.

A view north on Church Street shows Nast's Cut Rate secondhand store. The building housing Hays & Wormuth Insurance across the street was razed for the downtown mall. The steeple of the old Second Presbyterian Church is seen up the street. The church was destroyed in a spectacular fire in 2000, and a new United Presbyterian Church now occupies that location.

A young man is at the left edge of the picture. What became of him and the other young people on East Main Street? Mohawk Valley men already were being conscripted for a war America was not yet committed to.

When the military draft was instituted in late 1940, numbers were assigned and then announced on the radio. Victor DeGolyer and his friends gathered at the Socony gas station at East Main Street and Vrooman Avenue in Amsterdam's East End to hear the numbers called.

Less than a minute into the broadcast, DeGolyer's number was announced. He was first on a list of fifteen men who were inducted into the U.S. Army from Amsterdam on November 27, 1940.

The men were told they would serve for one year, but most fought until the war's end. DeGolyer was the personal radio man to Colonel Norman Schwarzkopf, the father of General Norman Schwarzkopf, American commander of the 1991 Persian Gulf War. DeGolyer was wounded during one battle with the German army, but the radio strapped to his back saved him from more serious injury.

DOWNTOWN THEATERS

It was raining when John Collier photographed two women and one man walking near the Strand, a movie theater on the south side of East Main Street. The Strand previously had been known as the Lyceum. St. Mary's Roman Catholic Church is across the street. The four small towers at the base of the steeple are no longer on the St. Mary's building. Collier's picture has a film noir feel to it.

The feature movie advertised on the marquee of the Strand was Mickey Rooney in *Life Begins for Andy Hardy*. According to Robert Going's book on Amsterdam during the war, in the movie, Andy moves to New York City and takes up with a worldly-wise woman who is married, although Andy doesn't know that. Going wrote, "Betsy Booth (Judy Garland) conspires with Judge Hardy to bring Andy to realize what is happening, and to his senses."

In 1949, the Strand was remodeled by the Gloversville-based Schine Chain Theatres and renamed the Mohawk. Mayor Burtiss E. Deal cut the ribbon for the Mohawk's opening attraction, *Take Me Out to the Ballgame*, starring Frank Sinatra. The Fort Johnson Drum Corps played. Tony the performing horse was on hand, and there was a motorcade featuring the Amsterdam Rugmakers baseball team.

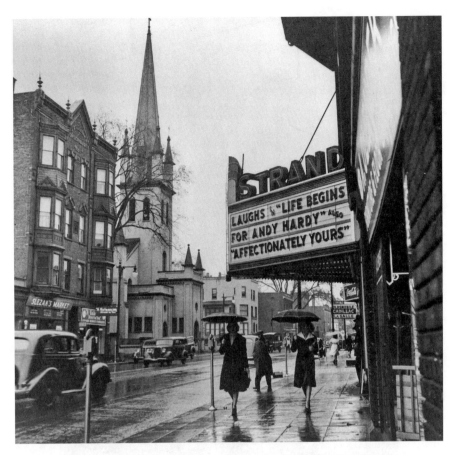

The Strand Theater on East Main Street in Amsterdam; St. Mary's Church is in the background. *Library of Congress.*

The last traditional movie theater constructed in downtown Amsterdam also opened in 1949, Brant Corporation's Tryon on East Main Street. The Tryon was built on the site of the McGibbon block, which had been leveled by a spectacular fire in 1943. The theater had sliding seats.

Champion, Amsterdam native Kirk Douglas's breakthrough boxing movie, was the opening attraction. The line to see *Champion* extended onto Church Street, according to local history fan Sam Vomero.

Entrepreneur Edward C. Klapp built the 1,400-seat Rialto Theater at Market and Grove Streets in 1917. In 1933, the Rialto became one of the Schine facilities and was known for live stage performances by the likes of Jack Benny and Burns and Allen.

Historian Hugh Donlon wrote that Amsterdam boxer "Sailor" Barron directed the Rialto usher corps: "Barron's ring expertise enabled him to administer fistic anesthesia to potential troublemakers so quietly that there was no awareness of the operation by most patrons." Bothersome customers were removed to an alleyway outside the theater.

The Regent, located at 19 Market Street, opened in 1914. The Schine chain remodeled the Regent in 1946, promising that everything was new but the name. The opening attraction for the rebuilt facility was *Weekend at the Waldorf* starring Ginger Rogers, Lana Turner, Walter Pidgeon and Xavier Cugat and his Orchestra.

The Orpheum on the west side of Market Street was known in the 1930s and 1940s for double-feature Sunday matinees, usually a Western and a B-thriller. There were no bathrooms in the Orpheum, and Mary Reilly, whose father was Orpheum operator Tom Shelly, said the Regent across the street made its bathrooms available to Orpheum patrons.

Hugh Donlon's son John didn't like the Orpheum when his father took him there as a child. "The smell of anti-vermin spray permeated the atmosphere, or maybe it was the smell of the films, 'C' or worse!"

The Rialto, Tryon, Mohawk, Regent and Orpheum are long gone, having succumbed to multiplex theater competition.

Opposite, top: East Main Street in the rain looking west toward St. Mary's Church. *Library of Congress.*

Opposite, bottom: Hardware store in Amsterdam. *Library of Congress.*

Chapter 6

Violins and Ginseng

Arch Kested was a violin maker and ginseng grower from Fonda who was the plaintiff in an assault case with political overtones. Several of his violins are in private collections. One such instrument is playable but has a small crack on the back. Inside is a label indicating it was made by A. Kested, Fonda, New York, in 1893. The fiddle's back and sides are maple, and the front is a tight-grained spruce. The pegboard and other parts are ebony. It is likely that the ebony parts were ordered from a catalog.

Born in Broadalbin in 1861 to Henry and Lydia Lansing Kested, Arch Kested married Charlotte Craig in 1891. He became proficient in "hand wood turning," according to his 1940 obituary. For years he was a woodworker at "the old steam mill" in Fonda. His obituary stated, "For many years he was recognized as an expert in the art of violin making and was consulted by many people who possessed violins of various makes."

Kested also was known as the "Ginseng King." Ginseng is a root crop that is processed and used to treat male sexual dysfunction and as a general health tonic to this day, especially among Asian people.

Cornell University has pictures from 1903 posted on a website showing Kested's ginseng farm on the Johnstown Road north of Fonda. Kested was reported to be shipping ginseng in two tin-lined hardwood barrels to China in 1905. In 1911, Kested and a partner were said to have a $10,000 ginseng crop on hand but were unable to sell the product in China because of a war there.

In 1915, Kested reported that his ginseng beds were raided twice within a month, and about $500 worth of the roots were stolen on each occasion.

The story reported that Kested sold ginseng in New York City for $3 to $8 dollars a pound. Kested's ginseng farm was estimated to be the largest in the United States in 1917.

No Verdict

Kested was the plaintiff in a politically charged assault case in 1922. Kested alleged that J. Hooker Cross and his son Irving Cross came to his barn and berated and beat him. The Crosses were upset at stories Kested allegedly was spreading about them, and the Crosses contended Kested started the physical fray with his pitchfork. The Crosses left the scene when Kested's wife appeared.

A jury in Fonda could not agree on a verdict in the case against the Crosses that June, according to the *Recorder*. The trial attracted attention as all three men were prominent (the elder Cross was superintendent of horses at the previous year's Fonda Fair) and involved in Republican politics.

When Kested died, his wife survived him, as did three sons and three daughters. Kested's obituary stated, "His genial personality and his kindness endeared him to a large circle of friends and acquaintances."

Another Violin Maker

John S. Hull of Fort Hunter also made violins by hand. The *Leader Herald* reported that at age eleven, Hull started to learn violin-making from his father, John Justin Hull, a violinist and instrument maker in Kingston, Pennsylvania.

The younger Hull trained to be a classical violinist at Wyoming Seminary in Pennsylvania and also studied with the Spanish master Raphael Todo. However, Hull ultimately focused on making and especially repairing violins in Fort Hunter. He was particularly good at repairing bows. He was reported to have "a large clientele of musicians who relied on his ability to keep their instruments in the peak of performing condition."

Chapter 7

Alex Isabel, Sports Champion from Pisciotta

Amsterdam was shocked one Sunday morning in January 1953 when city recreation superintendent Alex H. Isabel, fifty-three, died suddenly of a heart attack at his Forest Avenue home.

Isabel was also a Brooklyn Dodgers scout and basketball and baseball coach at St. Mary's Institute at the time of his death. Three years later, a Little League baseball field was dedicated in his honor, a field that still bears the family name on Upper Locust Avenue.

"He was never sick a day in his life," recalled Isabel's son, Gerard, known as "Pup," a nickname his father gave him. The night before his death, Alex Isabel spoke at a dinner of the St. Agnello Club, an Italian American organization in the West End where he spent much of his life. "Pup" Isabel passed away in 2012.

Alex Isabel's athletic skills became apparent when he played baseball for Amsterdam High before World War I, getting an offer from the New York Giants. Instead, he enlisted in the U.S. Navy and suffered hearing loss while on board the battleship Michigan.

After the war, Isabel finished high school and played baseball at St. Mary's Institute. He married Ann Murphy in 1923, and they had three children.

Isabel played and coached baseball in the popular semiprofessional leagues of the day. He pitched for the Gloversville-Johnstown Twin Cities and played and managed the Ticonderoga team in the Northern League in 1925 and 1926. He played for teams including the Mohawk Mills Karnaks, Tonquas Tribe and the West End Athletic Club of Albany.

In 1940, Isabel began coaching baseball at St. Mary's, adding basketball duties a year later. He became acting recreation superintendent for the city in 1944 when superintendent S. Joseph Golden was serving in the navy. Golden returned but resigned shortly after the war. Isabel became superintendent from 1946 until his death.

He spearheaded improvements at city playgrounds and led local baseball teams into national tournaments. He made college possible for many youngsters and was lauded for his efforts in fighting juvenile delinquency by keeping youth busy with productive pursuits. He brought in drama teacher Bert DeRose to begin a popular series of summer musicals.

As a scout for the Brooklyn Dodgers, Isabel scoured Upstate New York and parts of New England and Canada. His best-known find was Johnny Podres of Witherbee, New York, who pitched for the Dodgers in the World Series in 1953.

The week that Isabel died, recreation activities halted in Amsterdam. His funeral mass at St. Mary's Church attracted a huge crowd of state and local dignitaries, a Brooklyn Dodgers delegation, St. Mary's students and 115 boys from the Little League and Little-Bigger League.

At the 1956 dedication of Alex Isabel Memorial Field, committee chairman Nicholas DeCross stated, "It is hoped that the boys who play on this field will pattern themselves after Alex and attempt to pass on to their boys what he tried to instill in those who played for him."

Isabel's Restaurant

Brothers Guy, Hector and Alex were all involved in the operation of Isabel's Restaurant on West Main Street, although Guy and his wife, Ida, were the principal restaurateurs. "Pup" Isabel, who was a waiter at Isabel's for thirty-eight years, recalled that across from the restaurant on West Main Street in the old days was a public bath, next to a three-chair barbershop, candy store and a poolroom.

Amsterdam alderman Joseph Isabel, who grew up over Isabel's restaurant, said his parents, Guy and Ida, were great cooks. "He cut all of his own steaks and had a showcase in the dining room where you could pick out your own steaks.

After Guy Isabel died in the early 1970s, family members operated Isabel's until selling it to Mike Aldi in the early 1980s. Joseph Isabel said Aldi ran

the restaurant until he had a heart attack in the early 1990s. After that, it changed hands a few times before it closed.

Pisciotta

As do many West Enders in Amsterdam, the Isabels trace their roots to Pisciotta in southern Italy. Alex Isabel, for example, was born in Pisciotta and, at age six, came to New York City, where he lived on Little Italy's Cherry Street before his family settled in Amsterdam.

Pisciotta is a hilltop community near the Mediterranean Sea in the Campania region of Salerno province. St. Agnello is a popular saint in Pisciotta, and there used to be a St. Agnello feast day and a St. Agnello's Club in Amsterdam.

The streets of Amsterdam's West End were empty on warm summer evenings in the 1940s. To supplement the limited food available during wartime rationing, the Italian American residents were tending vegetable gardens on the fertile flat land between the railroad tracks and the Mohawk River. They grew peas, lettuce, carrots, dandelions and zucchini, much as their ancestors had done in Pisciotta.

Amsterdam residents whose roots are in Pisciotta include Rita Robusto Mucilli, Guy Capuccio and many others including the Sansalones, Catenas, Pepes, Petrosinos and Tambascos.

Mucilli said, "My father, Aniello Robusto, opened a barber shop, paint and glass shop at 123 West Main Street. He taught himself English words with the help of the Sears catalog nights, looking at pictures and putting the names together."

Aniello Robusto's name is inscribed on an altar at a church in Pisciotta as he helped raise money in Amsterdam for the structure.

Guy Capuccio's father and mother were both from Pisciotta. His father, Joseph Capuccio, came to America in 1910. Initially he lived in Syracuse but then joined friends from Pisciotta in Amsterdam, where he worked at the Sanford carpet mill. When World War I broke out, he served in the American military in France. He came back to Amsterdam and worked at the Mohawk carpet mill. He returned to Pisciotta to marry a woman from his hometown, Rose Tambasco. They came back to the United States for good in 1927.

Guy Capuccio visited his cousins in Pisciotta in 1991 and slept in the room where his mother was born. That home and many others are made

Many Italians who settled Amsterdam's West End came from Pisciotta, a hilltop community near the Mediterranean Sea in the Campania region, Salerno province. *Author's collection.*

of stone. Capuccio said, "You're going to a strange house, but the family's known. There's a difference."

Capuccio marveled at ancient fortifications in Pisciotta, built to head off an invasion by the Moors centuries ago. "When you look at a structure that's 1,400 years old, you say 'Wow.'"

Matthew Orante Was More Than a Haberdasher

O ne of old downtown Amsterdam's most unique stores was Matthews, advertised as the city's most exclusive men's store.

In 1952, Matthew Orante, who was a pattern maker for the New York State Thruway Authority and map coordinator at Scotia Naval Depot, opened a men's clothing shop at 30 Market Street. In 1964, he relocated to 40 East Main Street, and his sister's son, Dave Northrup, went to work for him.

Northrup wrote, "Matt Orante considered himself not only a haberdasher, but also an artist. In addition to men's clothing, that small place was crowded with his paintings and wood carvings."

The rear section of the second floor was devoted to a small art gallery and Orante's wife Isabelle's interior decorating business, Eljoor.

Northrup recalled, "The paintings that adorned the walls, the choice of clothing styles for resale, even the individually hand-lettered tags on each garment, every detail in Matthews bore the mark of the proprietor's personality."

Northrup said the Orantes lived most of their lives at 40 Division Street. "Matt decorated the front with paintings of the Orante coat of arms, and placed sculptures on the veranda in front of the top-floor apartment that was theirs."

Northrup lives in Rochester, and his essay on his uncle's store was one of the top winners in my 2012 Stories from the Mohawk Valley Contest. He wrote, "Before price points, bar codes, and scanners, in stores like Matthews one pursued a way of life rather than just made a living."

Matthew Orante's men's shop at its 30 Market Street location in Amsterdam. *David Northrup.*

Northrup has published a book of short stories based on Amsterdam and the surrounding Mohawk Valley called *The Memory of Broken Things*.

Matt Orante died in 2008. His wife, Isabelle Rajkowske Orante, died in 2011. Northrup said, "The son of Lithuanian immigrants, my uncle had an abiding faith, shared by many of his generation, that he could attain prosperity on his own, without the necessity of having to sell his labor to a large company."

Suits of Armor

Emil Suda of Amsterdam said the dark wooden door at Matthews on East Main Street was unlike any other men's store: "A block-patterned, plush off-white carpet with accents of red and brown was noticed upon entering,

Matthew Orante holding a sculpture in the art gallery of his East Main Street men's shop in Amsterdam. *David Northrup.*

along with the unusual atmosphere of the store itself, much like a museum rather than a haberdashery."

Suda recalled three suits of armor that he was told were obtained from Europe's Baltic region around Lithuania. There was one small suit of armor, and Suda was told that suit was for a young boy so he could be like his father, a knight.

Suda said items for sale included trench coats with an English look, heavy ivory cuff links, silver-headed walking sticks and amber stickpins.

Chapter 9

Carl August Johnson

An Immigrant's Tale

K arl August Johanesson, who went on to be a respected citizen of Amsterdam, New York, was born a woodsman's son in the village of Torp, Sweden, in 1872. He got up very early to deliver newspapers on his way to school three miles away, sometimes in fifty-below-zero weather. He read the papers before delivering them and picked up grocery orders to deliver on his way home.

His mother died, and when he was fifteen, Karl and his sister Kristina set sail for a new life in America. Over here, his name became Carl August Johnson. According to his granddaughter Diane Hale Smith of Amsterdam, "He wrote his new name over and over again in a journal to begin the transformation. I treasure that journal."

When Johnson arrived in Amsterdam, he worked at Inman Manufacturing Company on Guy Park Avenue in Amsterdam, a factory that turned out machinery for paper box making and paper cutting. Johnson was a diligent worker who trained as a machinist, toolmaker, coppersmith and electrician. Today the Inman building is a senior center.

Smith wrote, "When he turned twenty six he joined the Army, trained at the local armory and was sent to fight in the Spanish American War in 1898. Unfortunately he stepped on a scorpion and was sent home to recuperate. He reenlisted on September 6th 1899."

Back in Amsterdam, Johnson was a chauffeur for the Greens and Warnicks, prominent families. They treated him well. He drove one of the first motorcars in the city.

An 1889 letter of recommendation for Carl August Johnson from Inman Manufacturing Company. *Diane Hale Smith.*

Smith wrote, "He spent any free time he had at the local YMCA on Division Street. It has been said that he initiated basketball at the YMCA by hanging a coal scuttle on the wall, the way they often played in Sweden."

In 1905, he married Mina Kaiser at Saint Luke's Lutheran Church. They raised four daughters, including Smith's mother, Dorothy.

AUTO BUSINESS

Johnson became partners with Clarence Birch, operating a small garage at 78 Stewart Street. Johnson and George Calhoun later became partners and opened a large garage at 12–14 Market Street, behind the then Barnes Hotel.

Smith said, "They sold and serviced Case, Marmon and Hupmobile cars and parked over one hundred cars a night at the rate of one dollar each. They were well on their way to becoming wealthy businessmen when the stock market crashed. Due to a great amount of outstanding credit they had

given to their customers, the business closed. Their nonpaying customers became some of the wealthiest in Amsterdam."

Johnson found work at Fownes Glove in Amsterdam and retired at age seventy-nine in 1951. Smith wrote, "He was known for his honesty and was actually quite famous for it. Once when I was a teen I met an elderly man who remembered his generosity in accepting a Bible in exchange for mechanical work. He read that Bible completely four times and took it to heart applying it to his everyday life. My mother told me that when she wanted to be liked when meeting new people she would always say that she was Carl Johnson's daughter. Years later I did that myself mentioning that I was Dorothy Johnson Hale's daughter."

Johnson never returned to Sweden and lost touch with his Swedish friends. He enjoyed listening to records by Harry Stewart, who performed as Yogi Yorgesson, with an exaggerated Swedish accent. His daughter Dorothy secured the records for him while she working at Morrison and Putman's music store.

Johnson died of a heart attack in 1955 shortly after his fiftieth wedding anniversary and after receiving his sixty-year Masonic pin.

Smith said, "He would stay up until three in the morning reading National Geographics and dreaming of the day that we would walk on the moon. Sadly, he passed away before they did, but I imagine he was watching from somewhere else with that twinkle in his eye. He never wanted to miss anything!"

Chapter 10

Private Michael Lynch
Loved the Stage

Private Michael J. Lynch, twenty, a medical corpsman and former president of the high school drama club in Amsterdam, was bending down to tend to a wounded soldier in Vietnam when Lynch himself was

killed by gun or other small arms fire on March 15, 1969. According to a military website, thirteen soldiers from the Amsterdam area died in the Vietnam War.

Lynch had put his college career on hold and enlisted in the U.S. Army to serve with the First Battalion, Fifth Infantry of the Twenty-fifth Infantry Division. A friend said Lynch made that decision after hearing the song "The Impossible Dream" in the New York City production of *Man of La Mancha*.

Private Michael Lynch, an army medic from Amsterdam who was killed in Vietnam in 1969. *Nicholas Lynch.*

Originally posted to Germany, Lynch volunteered for Vietnam. He came home on leave for Christmas in 1968. His mother, Caroline Sampone Lynch, and younger brother Nicholas, sixteen, both then living in Hagaman, were with Michael for the last time in early January 1969 when they saw him off at the Schenectady bus station.

Nicholas Lynch has heard that his brother died either from enemy fire or friendly fire during the incident March 15 in Binh Dong Province. Michael's body was brought home and he was buried at Mount Carmel cemetery.

Nicholas Lynch said his brother was intense and idealistic. "He worried about the world, about racial problems. He was a wonderful person. He put his heart into acting and all that he did."

Michael wrote poetry, including a poem titled "Why?"

Why
If men were put on this earth
To toil and provide and
To love each other,
Must we live in a world like this—
Where freedom denied
Is certainly amiss?
Why
Must we live in fear of war, and therefore death?
Are we being punished for some sin?
And if not
Why is it that the innocent
Are those who never win?
Why
Must we kill each dark night many poor souls
In the name of Right?

Robert Lynch, Nicholas and Michael's father, had left the family when the boys were children. As the older son, Michael shouldered more responsibility after that happened. In high school, Michael looked up to drama teacher Bert DeRose.

DeRose said, "He was a very sensitive and caring young man who played various character roles in the school's drama productions. He loved the stage."

Michael played the father in *Mary Poppins* and *The Miracle Worker.* He was King Pellinore in *Camelot* and Max in *Sound of Music.*

After high school, Michael left for the state college at New Paltz. DeRose said Michael was excited to go there. A year later, DeRose saw his former student, and said, "He told me that he had quit college to join the armed services because he felt the need to serve his country."

HONORING MICHAEL

After DeRose and his former drama students lobbied the local school board, the newly renovated auditorium at what is now Wilbur H. Lynch Middle School in Amsterdam was named the Michael J. Lynch Theater on June 2, 2013. Lynch school is located on Brandt Place and is officially known as Lynch Literacy Academy.

Michael Lynch was not related to the man for whom the Lynch building was named. Wilbur H. Lynch was a school superintendent and Amsterdam

Aerial view of the Wilbur H. Lynch school building in Amsterdam in the 1960s. *Montgomery County Department of History and Archives.*

mayor. The Lynch building was the high school through 1977, and Michael Lynch, a 1966 graduate, performed on stage there.

Tom Stewart, now an announcer for New York City public television, was in *Camelot* with Michael, saying, "I remember him as having a larger-than-life personality, full of humor and warmth and love, which were all in his performance as King Pellinore, the befuddled monarch always out walking his dog."

Edward Schwartz of Troy, who also performed with Michael in high school, wrote, "He set a good example, both on-stage and off, by simply trying to do the right thing. Our hope is that a young person will see his name and ask, who is this? And, why?"

American Legion Post 701 Commander James Yermas and Michael Lynch knew each other as children. Yermas also served in Vietnam. Yermas noted that the Amsterdam Vietnam Memorial is located next to the flagpole on the hill outside the middle school. He said he hopes children who come to the theater will see the memorial with Michael's name and the names of twelve others who gave their all. Trees were also planted around the building in the 1940s in memory of those who died in World War II.

Chapter 11

Washington Frothingham

A Useful Life

The Reverend Washington Frothingham would be pleased to see how active the library is that bears his name in Fonda. A visitor to the Frothingham Free Library at 28 West Main Street often finds young and old reading books, using computers and discussing topics including local history.

A blue and gold historic marker outside the library pays tribute to Frothingham, who was born in 1822 in East Fonda and who died at his home in Fonda in 1914 at age ninety-two.

"My long cherished purpose is to establish a reading room and library in Fonda," Frothingham wrote. He left money in his will that helped establish the library.

Frothingham led a useful life, according to stories about his death printed in numerous New York State newspapers. Called the dean of American journalism, he was a syndicated newspaper columnist, book author, clergyman, missionary and philanthropist.

Frothingham's family—he was the third of ten children—moved from Fonda to Johnstown when he was a young child. Frothingham's mother was a niece of Washington Irving, and his father was a New York State judge. Young Frothingham wanted to be a writer, but to please his father and help the family, he moved to New York City and worked in a Broadway store for $1.50 a week, living on bread and water.

He secured a better retail job with Edwin D. Morgan, who proved a valuable friend. Morgan later was elected governor and then U.S. senator. After working some time for Morgan, Frothingham and a friend opened their own store.

Higher Calling

In 1850 at age twenty-eight, Frothingham felt called to the ministry. He sold his share of the business and prepared for the ministry at Princeton, developing skills as a speaker. His first position was at a Presbyterian Church in Guilderland. He opened a Sunday school and preaching station at an Albany machine shop. That effort led to the founding of Albany's West End Presbyterian Church.

During the Civil War, Frothingham was invited back to Fonda to restore the declining Reformed church. He succeeded, although his pro-Union political stance ran counter to the secessionist views of some church members. He was then called to serve the Tribes Hill Presbyterian Church, where he was pastor until 1905.

In 1862 at age forty, Frothingham married Mary Middlemass, a native of Scotland, who was a Sunday school teacher. Apparently, they had no children.

In the 1860s, Frothingham began writing columns on current events for newspapers throughout New York and Massachusetts including the *New York Times*, *Troy Times* and *Rochester Democrat and Chronicle*. He used pen names, most notably "The Hermit of New York" in Troy and "Macaulay" in Rochester.

Literary Pals

He was friendly with newspapermen and writers including Horace Greeley and William Cullen Bryant. He was the author of several books, including *A History of Montgomery County, N.Y.*

His writing kept him financially solvent as Frothingham was generous with the poor and active in creating public benefit institutions. He started a public bath in Fonda and even a bowling alley. When his work made him a frequent train traveler, he distributed religious tracts to the passengers. He held religious services at the Fonda jail.

After his first wife died, Frothingham married a woman who had been his wife's nurse, Ella Leavitt of Tribes Hill, a schoolteacher and correspondent for the *Recorder*. One source said among his first wife's last words were these: "Take care of Ella."

Ella, a brother and a niece were with Frothingham when he died two weeks after suffering a paralyzing stroke. The funeral was held at Fonda Reformed Church, and his body was cremated in Troy.

Chapter 12

Joseph Reaney of St. Johnsville, a Generous Man

The Margaret Reaney Memorial Library on quiet Kingsbury Avenue in St. Johnsville contains an in-house museum plus historical records that are helpful to genealogists. The museum temporarily closed in 2012 as volunteers and staff cleaned and refurbished the collections. The volunteers included Rebecca Sokol, Sharon Fuller, Paul Flanders, Mat Rapacz and Richard Bellinger.

Collections include Native American arrowheads and projectile points, items from Palatine German settlements, antique farm and carpentry tools, Revolutionary War–era powder horns, Civil War uniforms and buttons, glassware and historic photographs of St. Johnsville. There are church and cemetery records, scrapbooks, family histories and local newspaper archives.

At this writing, the Grand Army of the Republic Post flag from 1865 is on display. The flag contains the name of the soldier the GAR post was named after, Alonzo Smith, of the 115th New York Infantry.

The library has more than fifty paintings by European and American artists. The Victorian-style Memorial Room, used for speaking programs, contains sculptures, some by French artists of the nineteenth and twentieth centuries. The room also features a large hanging carpet from Tabriz, Iran.

MILLION-DOLLAR GIVER

The library building and many of the museum objects were gifts from textile manufacturer Joseph H. Reaney. His 1947 obituary estimated that Reaney, born in New Jersey, had made $1 million in charitable gifts during his eighty-two-year lifetime.

Reaney's father, also named Joseph, fought in the Civil War with the highly respected Fifth New York Volunteer Infantry, the Duryee Zouaves. The regiment was led by Colonel Abram Duryee and wore colorful uniforms, modeled after uniforms worn by French troops during the Crimean War.

The elder Reaney died five years after the war, leaving his widow, Margaret, to care for six-year-old Joseph. The family moved to Utica, where Joseph Reaney went to work at age twelve.

He held jobs to learn the knit goods industry and came to St. Johnsville to start a small mill in 1892. In 1898, he married Gertrude Horn of St. Johnsville. They had no children.

Reaney's Union Mills were built on New Street from Bridge Street to Kingsbury Avenue in 1900. He also owned or managed knitting mills in other municipalities in New York and New England. His mills were known for making women's underwear.

The library, named for Reaney's mother and opposite Reaney's home on Kingsbury Avenue, was built using funds donated by the manufacturer in 1909, the year his mother died. He also paid for the 1936 library addition.

"This building is to be a permanent home for the literature and arts of the community," said Reaney. The library sits in a park, also donated by Reaney, which abuts the buildings that formerly housed his knitting mills.

The textile manufacturer made many other public donations in St. Johnsville and was known for numerous private acts of charity.

ST. JOHNSVILLE

According to Kelly Farquhar's book *Montgomery County*, St. Johnsville is named either after an early surveyor, Alexander St. John, or the Dutch Reformed St. John's Church, where Joseph Reaney worshipped.

Palatine Germans settled the area in the 1700s. The 1747 Nellis Tavern is located just east of the village on Route 5. Fort Klock is situated about one mile east of the village, also on Route 5.

Early settlers included Jacob Zimmerman, who built gristmills. The first post office in the area was called Zimmerman's Corners.

The town of St. Johnsville was created in 1838 from the town of Oppenheim. The township contains 11,100 acres, making it the smallest town in area in the state. The village within the town was created in 1857.

F. Engelhardt & Sons made player pianos in St. Johnsville from 1889 to the 1930s. Other past manufacturers included a condensed milk plant, tool factories and shoe and knitting mills.

Chapter 13

Boss Jacob Snell

A Big Man in Politics

Jacob Snell was a large man. Snell also loomed large politically in Montgomery County and New York State in the late nineteenth and early twentieth centuries. When he died, newspapers called him "one of the best known Republicans in the state."

Boss Snell's girth made him an easy target for political cartoonists. A *New York Journal* cartoon in 1901 showed a seated Snell with a diamond stickpin on his tie. His large stomach elevates the stickpin to his line of sight. The caption said, "Jacob Snell, whose diamond looks him square in the face."

Snell was born in Stone Arabia in the Town of Palatine in 1847 and lived on a farm with his parents until about 1870 when he moved to Fonda. While in Palatine, he was elected supervisor and town clerk running as a Republican in a Democratic town.

His great-grandfather, another Jacob Snell, fought in the American Revolution, was a state assemblyman for five terms and county sheriff. Another ancestor, Alexander Snell, also had been elected sheriff.

Snell ran for sheriff in 1884 and lost but was elected in 1886, serving three years. He also served as chair of the Republican county committee and was a state committeeman and president of the village of Fonda. He frequently attended Republican state political conventions. His efforts were said to have turned the town of Mohawk, which contains the village of Fonda, from Democrat to Republican.

He was superintendent of a section of the Erie Canal for a time. He had a company that did roadwork and was president of Mohawk Valley Broom

Company of Fonda. He owned a downtown Fonda hotel, later known as the Hotel Roy. He was president of the County Agricultural Society for two years.

Snell knew President Theodore Roosevelt. A 1903 letter in the Library of Congress from Snell to U.S. senator and Republican political boss Thomas Collier Platt asks for the reappointment of John Van Antwerp as postmaster in Fultonville. Snell references a meeting with Roosevelt at the President's Oyster Bay home on Long Island.

PRISON WORK

In November 1903, Governor Benjamin Odell named Snell the warden of the Napanoch reformatory in Ulster County. Snell had wanted the post of warden at Dannemora prison, but the Ulster County job had the same $3,500 yearly salary, according to the *Kingston Freeman*. Plus, Snell's family had use of a furnished house with servants, food, horses and carriages. The *Amsterdam Recorder* reported Snell was "an intimate friend" of the governor.

Snell had just come through a rough political patch. He had given up a claim for a nomination to the State Senate with the promise of the prison job. But Republican congressman Lucius Littauer fought against Snell's nomination, apparently delaying the appointment, miffed that Snell had supported John Stewart of Amsterdam in a battle with Littauer for the Republican endorsement for Congress.

The *Times* wrote, "Littauer managed to give the impression that he was the particular candidate of President Roosevelt and he secured the nomination. There has been bitter feeling ever since." Littauer and President Roosevelt had been roommates at Harvard.

While on the job as prison warden, Snell split his time between Napanoch and Fonda and continued as Montgomery County GOP chairman.

His health began to decline. He died at Napanoch reformatory on December 22, 1905, at age fifty-eight. The *Schenectady Union* wrote, "An abdominal abscess and acute kidney disease, surgical treatment of which was not practicable because of his immense girth, were the primary causes of his death."

There is an often repeated story that when Snell died, the door of the room where he perished had to be enlarged to get his body out.

DEFENDING SNELL

Amsterdam's Democratic paper, the *Morning Sentinel*, in a way came to Republican Snell's defense on the subject of his size. The *Little Falls Times* had reported that Snell weighed five hundred pounds and that twelve men were needed to carry his casket. The *Sentinel* scoffed at the *Little Falls* report, saying Snell did not even weigh four hundred pounds and that "six small men" had no trouble handling the casket.

At the funeral in Fonda, Reverend Washington Frothingham paid tribute to Snell's Revolutionary War ancestors, saying seven of them had given their lives for their country. Snell's body was taken by train for burial in the Canajoharie Falls Cemetery. He had married Nancy Nellis of Palatine in 1867, and they had two sons and three daughters.

The *Canajoharie Courier* editorialized that Boss Snell was "unceasing and unrelenting" on behalf of the Republican Party "A campaign once begun was waged until the polls were closed on election day, so in case of a narrow defeat he never felt the chagrin that he had not made his best and most ardent fight."

Chapter 14

An Artistic Gunsmith

A loom fixer for an Amsterdam carpet mill set up shop as a gunsmith in 1948 and then made his living building custom rifles and repairing firearms until his death in 1960.

Raymond Overbaugh, born in 1903 in the town of Florida, once told a reporter, "I always fooled around with guns in my spare time." He worked twenty-eight years fixing looms for Bigelow-Sanford's Amsterdam carpet mills before opening his gun shop in a small building next to his home off Route 5 near Cranesville. Later he moved his family and shop to Tribes Hill. Overbaugh's shop in Tribes Hill was in a one-car garage on Second Avenue Extension.

Many American soldiers returning from World War II brought souvenir weapons home, in particular Mauser rifles made for the German army.

According to a 1953 story by Truman Temple in the *Daily Gazette*, Overbaugh's bestselling items were deer hunting rifles converted from Mauser 8 millimeter rifles. He turned out about thirty rifles a year, plus doing repair work.

"The 'Overbaugh Special' is in demand all over the country by certain small arms fanatics who can pay the necessary $110 (and up) for a hand-crafted rifle that combines German precision with light handling qualities," Temple wrote.

Overbaugh knew his hunting customers wanted a firearm much lighter than the one German soldiers carried. He trimmed about a fourth of the weight off each Mauser, and the finished product weighed seven pounds.

"I just trim down the stock and take a bit of metal off here and there," Overbaugh said.

Today, Overbaugh's rifles are seen infrequently at gun shows and can go for $2,000 each, according to firearms fanciers.

John Del Savio, an official of the Pine Tree Rifle Club in Johnstown, said an Overbaugh rifle was known for having diamond-shaped inlays, black and white. The black inlays were made from ebony, and the white inlays were ivory. Overbaugh also put a tiny signature on the barrels of some of his guns.

Floyd King wrote that he owned an Overbaugh rifle modified from a German Mauser. "Every deer that I shot went down and I never had to chase a deer after I had shot it."

VISITING THE SHOP

In the early 1950s, Johnstown native David Acker and his father, gun collector Adolph Acker, used to visit Overbaugh's shop in Cranesville. It was a small space that could comfortably handle a half dozen people.

During one visit a customer came in and inquired about a special firearm order. After he left, the word was passed that the customer was Amsterdam native Kirk Douglas, home for a time from Hollywood.

Overbaugh said in the 1953 interview that his oddest repair job was work done on two submachine guns for the Amsterdam police. Local police carried the weapons on those days when the carpet mills paid workers in cash. Overbaugh said police never had to fire them.

Overbaugh favored Colt automatic weapons. He said that the Germans made the best rifles, the British made the best shotguns and the best revolvers were made by Smith & Wesson in America.

Reporter Temple said that Overbaugh's shop was surrounded by tame squirrels and birds. "He walked to the door and coaxed chickadees down to feed from his hand."

At the time of the interview, Overbaugh had two hundred guns in his collection, including a German machine gun from World War I that he kept in the basement. His shop was hard to find, and he had toyed with the idea of painting the machine gun and putting it in front of his shop as an advertisement. Overbaugh's collection also included a half dozen pistols dating from the American Revolution.

Overbaugh died in 1960 and was buried at Amsterdam's Fairview Cemetery. His wife, Olive, and son, George, survived him.

After his father's death, George Overbaugh continued working at the shop until it was taken for the expansion of Route 5 around 1970. George Overbaugh died in 2008 at age eighty-one and was living on Stoner Trail Road in Fonda. His obituary reported that he had a deep interest in guns and old cars and enjoyed playing banjo and keyboard.

PART II
Places We Knew

Chapter 15

Sportsmen's Shows
Drew Thousands to Amsterdam

Larrabee's hardware and sporting goods store on Market Street was selling Ike Walton fishing boots for $6.95 in March 1937 as over a thousand hunters and fishermen attended the annual Sportsmen's Show in Amsterdam. Put on by the Amsterdam Fish and Game League from the 1930s into the 1950s, the shows were held in the gymnasium, auditorium and classrooms of the former Theodore Roosevelt Junior High on Guy Park Avenue during the school's Easter vacation.

"It was a big thing," said city resident Mario Checca. "They chopped wood, sawed wood and rolled logs on the water."

The league formed in 1931, and the annual shows began in 1933, first at the South Side National Guard armory and then the junior high. Some years were missed during and after World War II, but the event resumed with an entire week of activities in the late 1940s, attracting tens of thousands of visitors. Proceeds helped pay for fish stocking and other conservation work.

The men of the league became famous for hearty pancake suppers served in the junior high cafeteria. There were canoe tipping, ax wielding, fly-casting and sharp shooting competitions and demonstrations, along with professional exhibits. In 1937, the show featured the world's biggest snowshoe, sent by a Maine manufacturer.

Entertainers were brought in. One local native recalled a performance by a young Minnie Pearl. In 1938, league members put on a skit called "Trappers' Justice" in which local marksman W.H. Jacoby hit the bullseye on a card held by Robert Knapp, while Art Grass played the

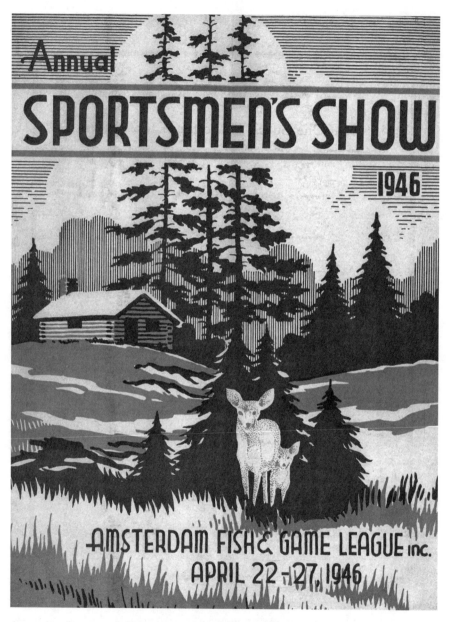

Amsterdam Sportsmen's Show program, 1946. *Charles Wharton.*

World's biggest snowshoe hanging on the junior high gymnasium wall in Amsterdam. *Charles Wharton.*

harmonica. Leyman and Arnold Watson of Hope Falls won the men's log sawing contest that year while Mildred Moore and Sarah Colson won the women's competition.

In 1946, the show featured state lumberjack championship events. There was no show in 1947, but in 1948, the event ran for eight days, featuring live bears and trick log rollers from Michigan. An estimated twenty-five thousand attended. There was a live radio broadcast by Gloversville station WENT.

Local banker Charles Wharton, who died in 2004 at the age of ninety-seven, was founding treasurer of the fish and game league and a prime mover in organizing the annual shows. Wharton said that people came from all over the state on buses and up from New York City to "see how we did things."

"Real pine logs right out of the woods," Wharton said, were used for the log rolling competition. So many pine boughs decorated the junior high, he said, that "the place smelled like the north woods."

Adirondack hermit Noah Rondeau used to put on a demonstration, setting up a camp inside the school. Rondeau came out of his hermitage in the Cold River area of the western high peaks, sometimes with help from a state helicopter, to appear in many New York sportsmen's shows in the 1940s and 1950s.

Camping scene at Amsterdam Sportsmen's Show. *Charles Wharton.*

Theodore Roosevelt Junior High in Amsterdam, demolished in the 1970s. *Gerald Snyder.*

The Amsterdam shows ended sometime in the 1950s, after professional entertainment companies that competed with the volunteer event asked the State Education Department to rule if it was proper to hold the shows in a public school.

Historian Hugh Donlon said the answer from the state was "an official frown," adding, "That brought an end to one of the most ambitious and successful community undertakings ever recorded in the valley."

Junior High Vanishes

The junior high where the Sportsmen's Shows were held was built in 1924, and the old high school behind it was attached to the new building. The high school dated from 1904 and was replaced by the Wilbur H. Lynch High School off Bunn Street extension in the 1930s. Lynch today is the middle school, and the high school is in the town of Amsterdam.

The junior high on Guy Park Avenue was demolished in the 1970s, replaced by the Theodore Roosevelt senior apartments.

The Restaurant on the Hill

The Tower Inn on Route 5 in Cranesville, owned by Marion and Fred Bennett, was famous for its round tower with a pointed roof, Duncan Hines ratings, orange dinner rolls, upscale clientele and cats that had the run of the place. The building, which sits atop a small hill, is still a restaurant today, Valentino's.

Marion Campbell and Fred Bennett married in 1912 in Marion's hometown of Westerly, Rhode Island. She was twenty-one, and he was twenty-eight. Their attraction may have stemmed from Fred's good looks and horsemanship. He was winner of several Richfield Springs races on his stallion, Pete.

Fred was originally from Milford, New York, and had worked out west on the Northern Pacific Railroad in Montana. The Bennett family purchased a cattle and horse farm in Fultonville from the John Starin estate.

After their wedding, Marion and Fred lived at the Fultonville farm for a time, and then the family purchased Adriutha Farm in Cranesville east of Amsterdam in 1923. They bought the adjacent summer home of the Morris and Nisbet families in 1927 and opened the Tower Inn as a restaurant. Some of the couple's money may have derived from Mrs. Bennett's mother, Mary Betty Chapman Campbell Lockwood, who lived with them at the Tower. There was a Southern aura about Mrs. Lockwood and the restaurant's recipes.

The Tower Inn was recommended by pioneer traveling food critic Duncan Hines starting in 1937. The movers and shakers in the area beat a path to the door, even during gasoline rationing in World War II.

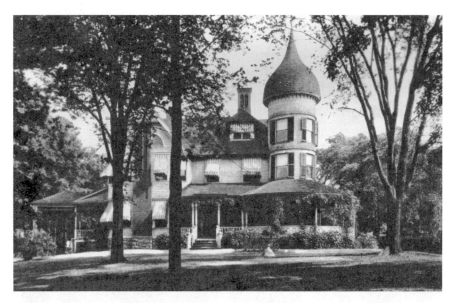

A postcard view of the Tower Inn in Cranesville. *Gerald Snyder.*

A young Fred Bennett (top row, far right) next to Marion Bennett, who became owners of Cranesville's Tower Inn. *Nancy Berggren.*

Far left, Fred and Marion Bennett. Second from right, Governor Thomas Dewey. *Nancy Berggren.*

Fred Bennett died in 1946 from heart trouble. The *Recorder* described him as a cordial host and pleasant companion. Marion Bennett, her mother and the cook, Loutie Myers, continued living at the Tower, along with three cats. A tiger cat belonged to Myers on the third floor, and Mrs. Bennett had two troublesome Persian cats—Brucie and Dickie. They also had a dog.

My cousin, Betty Segen Pronk now of Scottsdale, Arizona, was a waitress at the Tower from her senior year in high school in the late 1940s through her early years as a teacher.

Pronk said, "Dickie was usually the worst cat, but one time after we girls had set a big dinner, Brucie came tearing down the stairs and went flying down the banquet table. We had to start all over again." Historian Hugh Donlon complained that Bennett's cats had the run of the place.

The main line of the New York Central Railroad was close to the Tower, and waitresses swept the porch daily to get rid of cinders. Before Route 5 was widened into a four-lane highway in the 1960s the restaurant also had a graceful, wooded front lawn.

Specialties included half a baked chicken (the staff meal), steak, fish, ham and lobster. Delectable dinner rolls and sweet cinnamon buns were baked first by Mrs. Lockwood and then by Mrs. Bennett. In 1948, steak cost $5.00, and chicken was $2.50.

A Friend of Dewey

Mrs. Bennett was active in Republican politics and a friend of Governor Thomas Dewey, an unsuccessful presidential candidate in 1944 and 1948. When the 1948 election approached, Mrs. Bennett wondered if Pronk's parents—Peter and Jane Segen—would vote for Dewey. Pronk said her mom would, but her father couldn't, as he wasn't a citizen, lacking papers from when he came from Ukraine. Mrs. Bennett fixed it so Peter Segen became a citizen and a presumed Dewey supporter.

Amsterdam's doctors, lawyers, bankers and mill executives dined regularly at the Tower. People rushed there after the Saratoga horse races in the summer, as the restaurant stopped serving at 8:30 p.m.

Amsterdam native Donald Isburgh wrote, "I remember eating there on many occasions, not the least of which was a small family dinner just before our marriage. My father was always uncomfortable there due to his large size and having to sit in small chairs.

"I remember the sticky buns, the Otsego bass (which Mrs. Bennett had brought to the restaurant daily by a fisherman from Cooperstown), and that no alcohol was served. Sometimes, we'd have a short cocktail in the parking lot before going in for dinner!"

Norma-Jean Qualls was the daughter of a single mother who worked two jobs, as a Tower waitress and a teacher. Qualls, who was four when her mother started at the restaurant, said, "I 'helped' Mr. Bennett greet customers and assisted the 'girls' in setting up the tables late at night. Often I would fall asleep on the floor—it was long past my bedtime.

"They had an Oldsmobile two-door coupe with a large trunk, and it was a workhorse. Mrs. Bennett would load it with a barrel of live lobsters from (I think) Quandts, fresh veggies from the Menands Market where she drove at least once a week, or to Cooperstown to get Black Angus steaks. She also picked up her peppermint ice cream from Voorhees Ice Cream shop on Prospect Street—in metal cans. I traveled with her on many of these trips."

Marion Bennett, Republican political leader
and proprietor of Cranesville's Tower Inn.
Nancy Berggren.

Nancy Sieper Berggren of Ballston Spa is the great niece of the Bennetts. Her mother was Marion Bennett's niece, Jean Bennett Sieper, who worked summers at the Tower while at Johnstown High School and St. Lawrence University. Berggren said Mrs. Bennett was a hard taskmaster but also a benefactor after Berggren's mother lost her own mother.

Berggren said, "I remember yearly visits during the 1950s to the Tower Inn to see my great-aunt and having a very short visit upstairs to say hello to her very elderly mother, Mrs. Lockwood. And even then Loutie the cook was in the kitchen. I have two papier-mâché birds on my Christmas tree every year that were gifts to me as a little girl from Loutie."

Mrs. Bennett succumbed to cancer in 1960. She was sixty-nine. When she died, she was vice-chairman of the Montgomery County Republican Committee. Her funeral was held at the restaurant; she and her husband are buried in Rhode Island. Mrs. Bennett's mother outlived her daughter, spending her last years on Market Street in Amsterdam.

Mrs. Bennett's niece Jean traveled from her home in Minnesota to Cranesville for the funeral and put the property up for sale.

DINNER ROLLS

William Weeper Sr., of Selma, Texas, has provided the recipe for the Tower's famous orange dinner rolls. Weeper is related to the Bennett family and is a former resident of Fonda.

Weeper said, "Dinner rolls were made from Parker House roll mix (hard to find today, but you can find a receipt and make your own). Once you have the Parker House roll dough, you make it in round balls about 1½ inches in diameter. Place dough balls in a roll pan (greased) and let them rise until full. Punch a hole in the center and place one-half cube of sugar in hole. Add about a teaspoon of orange juice, let rise again. Bake in oven until brown or until you can place a toothpick in and pull out (dough should not stick). These were the Tower's and Bennett's famous Orange Rolls. Delicate."

Chapter 17

Camp Agaming in the Adirondacks

When the late Lauren "Bud" Barnett was covered with mud in European foxholes during World War II, he took his mind off his soldier's plight by dreaming of the beauty of the Adirondacks. Wounded in Germany, when the war ended, he used his muster pay to buy land and build his own Adirondack camp.

Barnett's parents, insurance agents in Amsterdam, already had a camp in Wells, and Barnett had been a regular two-week summer camper during the 1930s at YMCA Camp Agaming. The camp played a special role in the upbringing of boys who went on to be the men of the "greatest generation."

"I longed to come back to that spot," Barnett said.

Said to be an Indian word for "along the shore," Camp Agaming (pronounced agh-uh-ming) was on the north shore of Lake Pleasant near the inlet stream from Sacandaga Lake and the village of Lake Pleasant.

The Gloversville YMCA owned the property and started the camp in cooperation with the Amsterdam YMCA in the 1920s. There were Lutheran and Jewish summer camps nearby.

Attendance at Camp Agaming dwindled during and after World War II. The property was sold in 1965, and camp buildings were converted into private residences.

The Fulton County YMCA on Harrison Street in Johnstown still calls its summer day program Camp Agaming in tribute to the residential summer camp of days gone by.

The 1930s

In the 1930s, a fair number of campers were on scholarship and did kitchen work in addition to participating in activities. Some came from the Capital District or downstate, but most were from Fulton and Montgomery Counties. During the school year, the YMCA held bean suppers in Amsterdam to promote the next season.

"Agaming, Agaming, we get up when the birdies sing," began the camp song. "Where the green grass grows and it never snows at Agaming." Today's Fulton County YMCA day campers still sing a similar tune.

At camp the boys learned archery, played softball and basketball and went fishing and swimming. Occasionally campers played softball against other camps. Skits were put on during nightly campfires.

One 1938 camp counselor, Isadore Demsky, became the movie actor, Kirk Douglas. Other counselors were William Blase, who went on to be an Amsterdam physician, and Bob Quiri, who was one of the principals of Ruby & Quiri home decorating.

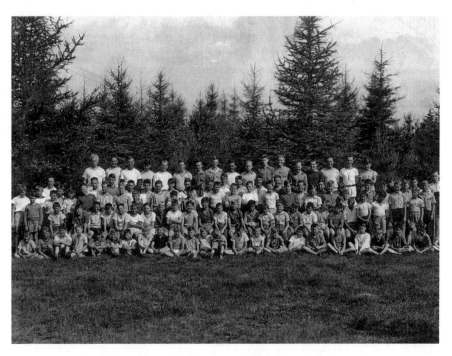

Camp Agaming group shot from the late 1930s. Counselor Isadore Demsky, who became actor Kirk Douglas, is sixth from right, top row. *Author's collection.*

Camp directors included "Skipper" Jackson from the Gloversville YMCA, excellent at table tennis; Walter Van Hine from the Amsterdam YMCA, an accomplished tennis player; and Don Hale from Gloversville, a skilled fisherman.

There were one-day and overnight hiking and canoe outings, with a three-day trip to climb Mount Marcy, the state's highest peak. To get to Mount Marcy, campers rode in the camp truck or authentic "woody," a Ford station wagon with wooden sides.

An Important Stage of Life

"It was just about the last stage of your life before you noticed the absence of girls," said John "Bud" Rees in a 2002 interview. Rees served on the ground crew for a squadron of P-38 fighters in the South Pacific during World War II.

"I remember one of the campers, David Wells, who died in the war," Rees said. "He was a nice young man. It seemed that those who died in the war were the nicest."

Camp counselor Demsky/Douglas made an impression on Rees. "He had muscles growing out of his muscles. He was very popular with the younger folks, but most all the counselors were."

Demsky/Douglas had charge of the waterfront, and according to Rees, "I can remember seeing him in the back of a canoe. He looked like a much healthier Charles Atlas."

Rees grew up in Chicago but spent summers with his Amsterdam grandparents, the Brannocks. He retired from an English professorship at Kansas State University.

Bob Dunning, who followed in his father's footsteps to become an Amsterdam dentist, attended Camp Agaming for parts of three summers in the late 1930s. Dunning served in the navy in World War II; he died in 2011.

"It was near enough so that it wasn't hard to get there," Dunning said. "Everyone knew someone who was also going. It was a good way to learn to swim."

A Week of Fun

Pat Constantine of Amsterdam recollected:

I'm going back to the year 1939. The plan the YMCA had back then was to more or less treat mostly underprivileged kids to a week of fun.

They would choose a group of children, load them on a truck with their duffel bags, shopping bags and boxes with their belongings. When we got to camp, they would assign eight kids to each cabin, plus one counselor.

Every morning they would sound reveille and raise the flag. We would assemble around the flagpole, all of us in our birthday suits. After the flag raising, they would give an order to take your morning dip. It was a necessity that in your goodie pack, you had to bring a bar of Ivory Soap, the kind that floats.

During the week they treated us to a play at the Tamarack Playhouse. Another day was a trip to Tupper Lake Mountain where there was a fire ranger station. We all had a chance to climb the ladder to the top to see the beautiful mountain view.

Then there was a sports company's CEO who would treat us to a buffet, then he gave us all baseballs, gloves and whatever they had to give.

Most of us underprivileged kids paid our dues by taking out the trash in the winter at the YMCA, shoveling snow and sweeping the club rooms after each meeting.

Chapter 18

A Bleecker Perspective

B leecker, a town in northern Fulton County, had a population of 533 in the 2010 census but in 1860 boasted twice that many people, many of them employed in lumbering and tanning.

The town apparently was named after Barent Bleecker, one of three men who purchased a land patent in an auction held in Albany in 1793. A land patent is granted by the government and is the best evidence of the right to own property. Bleecker's partners were Cornelius Glen and Abraham Lansing, and the area originally was known as Glen, Bleecker and Lansing's patent. Parts of two other patents, Chase's patent in the north and Mayfield's patent in the south, comprise the remaining land in Bleecker.

There is a funnier story about how the town got its name. Two men were lost in the Adirondacks, and one of them climbed a tree to survey the situation. The man on the ground asked the man in the tree how it looked. His reply was, "Bleak." The man on the ground responded, "It is bleaker down here."

The town of Bleecker was created in 1831 from part of the town of Johnstown. Some of Bleecker's land was returned to Johnstown in 1841, and another part was lost when the town of Caroga was created in 1842.

Historian Washington Frothingham wrote in 1892 that Bleecker's most important industry was lumbering, even though "much of the valuable timber has been cleared away." The leather tanning industry had largely come and gone by 1892. Hemlock bark was used to tan raw skins into leather.

Farming in the hilly and stony town has always been difficult. One saying goes, "When you buy meat, you buy bones; when you buy Bleecker, you

Students and teacher pose at the Factory School, District Number 3 School in Bleecker, New York, in 1910. The building today is a private museum. *Nancy Bleyl.*

buy stones." Also, town historian Eleanor Bleyl Brooks said Bleecker is at a high enough elevation, so its growing season is often shorter than nearby communities. People refer to a mountain ridge that can be seen from Gloversville as Bleecker Mountain.

The Bleecker Historical Society has organized a well-attended speakers program and is creating an artifact collection at the town hall on County Highway 112, where the society meets. The historical group is working on a documentary film based on oral history interviews with town residents.

The town once had four churches and six schools. Historian Brooks, who has lived all her life in Bleecker, said that when her father was town clerk, municipal business was conducted around their dining room table as there was no town hall. Today's town hall is a former school building.

Bleecker resident Nancy Buyce owns District Number 3 schoolhouse, sometimes known as the "Factory School" or "Tannery School." Buyce attended school in the building, which was constructed in 1873 and closed in the 1950s. Buyce believes there were two previous District 3 buildings.

The structure is on Lily Lake Road in what was called Bleecker Village, which in the nineteenth century boasted a sawmill, tannery and other manufacturing sites. The building still contains children's and teachers' desks, even books, maps and schoolwork. Buyce operates it as a private attraction called the Old School Museum.

A stagecoach is the symbol of the town and the historical society. Brooks said that the phrase "Bleecker Stage" refers to how mail used to be delivered. Mail was shipped to Johnstown and later Gloversville, then dispatched on the "Bleecker Stage" to two early post offices in town, at first by horse-drawn vehicle and then automotive. The last post office in Bleecker closed in the 1930s, after which mail was delivered directly to residents' mailboxes. Today, "Bleecker Stage" has been lost to 911 highway addressing.

Some former city dwellers have found picturesque Bleecker to their liking in recent decades and extended vacation stays into year-round living. All of Bleecker is inside the Adirondack Park. Housing has been developed on the west side of Bleecker around Peck's Lake.

Chapter 19

Favored by Nature,
the Sassafras Bird Sanctuary

C lose to seven thousand people visited the Sassafras Bird Sanctuary in
Amsterdam in 1934. The private park opened in 1931, spearheaded by
two formidable city institutions—the Century Club, composed of prominent
women, and naturalist Walter Elwood.

Sassafras is a kind of tree with aromatic leaves and bark used to make tea.
The area called Sassafras Hollow is in west Amsterdam along Dove Creek.
The land was the nineteenth-century estate of the Carmichael family.

In 1912, Henrietta Carmichael offered the city twenty acres in Sassafras
Hollow for use as a park. Carmichael wanted the land named Stewart Park,
in memory of her father. Although Mayor Jacob Dealy was interested, the
city did not acquire the land at that time.

In January 1931, Walter Elwood wrote an essay extolling the beauties of
Sassafras Hollow, including its fifty varieties of birds. "Wooded ravines are
always attractive, but here is one so specially favored by nature that we would
have to go far and look hard to find another holding out so much for us."

That May, the Sassafras Bird Sanctuary opened as a private park on land
owned by Elizabeth Carmichael, Francis Morris and Helen Sugden. Elwood
had expressed concern over hunters endangering bird watchers, so firearms
were banned. The Century Club managed the sanctuary, and a warden was
hired to enforce the rules.

The Sassafras Bird Club was created, and its activities were chronicled in
the newspapers. Elwood, a teacher who later founded the museum that bears
his name, was the club's first president. In the 1930s, trees were planted,

Dove Creek today in what was Amsterdam's Sassafras Bird Sanctuary. *Gerald Skrocki.*

and trails, bridges and fireplaces were built. An outdoor amphitheater and trailside museum were constructed. The children of New East Main Street School prepared a Christmas tree with food for the birds every year.

In June 1934, Grace Kyle led an evening stroll at Sassafras, according to a *Recorder* newspaper account: "The first thing to greet the club members was a pair of lovely bluebirds busily engaged in preparing supper for their young in a nearby bluebird house." A garden had been planted to demonstrate the crops favored by local Indians. The walk focused on ferns growing in the sanctuary. Walkers also saw a "showy lady's slipper" with thirteen blossoms.

Twenty people attended a spring walk through Sassafras in April 1935: "The advance of the season was shown in the green leaves of the arbutus and the first blossoms of spring beauties and coltsfoot. On a trail through the open spaces twenty different kinds of birds were observed." Among the birds sighted were the vesper sparrow, hermit thrush, tree swallow and fox sparrow. The walk was followed by a campfire breakfast.

Walter Elwood died in 1955, and neglect of the Sassafras became an issue during the 1950s. The trailside museum went up in smoke. Amsterdam native Bruce Northrup recalled, "The neighborhood residents turned out in numbers to look over the ruins."

Above: A flower at Amsterdam's former Sassafras Bird Sanctuary. *Gerald Skrocki*.

Left: Graffiti on the fireplace at the burned-out trailside museum at the former Sassafras Bird Sanctuary. *Gerald Skrocki*.

Fallen trees along the trail at the former Sassafras Bird Sanctuary. *Gerald Skrocki.*

There were ups and downs. Boy Scouts placed one hundred birdhouses in the park. When the now closed Clara Bacon Elementary School was built on Henrietta Boulevard in 1966 at the entrance to the Sassafras, wiring was put in for the sanctuary's outdoor amphitheater, and programs were put on for awhile. However, by 1970 the birdhouses had disappeared, and the electrical box for the amphitheater wiring was ruined by a shotgun blast.

In 1971, Bacon school students once again began working on improving the bird sanctuary. Later an elaborate playground called the Sassafras Safari, still in use, was built near the school.

Historian Hugh Donlon wrote in 1980, "Preservation programs were begun and abandoned in sequence and discouragement before onslaughts by destructionists operating beyond pale of official protection."

Outdoor enthusiast John Naple said of his last visit to the Sassafras, "It is a great place but needs some love. There were wildflowers in the woods. Trails were passable but there was litter and blow-down along the trails."

Gloversville's Field of Dreams

G loversville Little League games take place at Parkhurst Field on Harrison Street where major leaguers Honus Wagner and Cy Young played in 1907. "Moonlight" Graham played on the field that year as well. The field once hosted teams such as the Philadelphia Colored Giants and the Cuban Giants of the Negro League. An exhibition game took place there in 1914 featuring the New York Bloomer Girls.

AJ & G Park

The Fonda, Johnstown & Gloversville Railroad (FJ&G) built what was initially known as AJ&G Park as a tourist attraction and stop on the railroad, which connected with the New York Central in Fonda. AJ&G stood for Amsterdam, Johnstown and Gloversville.

Opened on July 12, 1906, the ballpark was at first home to the champion professional New York State League JAGs (Johnstown-Amsterdam-Gloversville). The grandstand seated 1,500 people.

The rail link made the field convenient for major league teams on exhibition tours. The Boston Americans played in Gloversville on July 5, 1907, with their player/manager, Hall of Fame pitcher Cy Young. The *Johnstown Daily Republican* headlined, "Snappy plays delight crowd; Boston Americans took the game but it was a joy to see them play ball."

The dedication ceremony for AJ&G baseball park in Gloversville in 1906. Grandstand and clubhouse are at left, National Guard soldiers on the field. *David Karpinski.*

Archibald Wright "Moonlight" Graham played with the minor league Scranton Miners at the Gloversville ballfield July 16, 1907. Graham played right field in a single major league game for the New York Giants in 1905. He never had a major league at bat and was sent back to the minors, later becoming a doctor. His story was featured in the 1989 movie *Field of Dreams.*

The Pittsburgh Nationals and Honus Wagner, destined for the Hall of Fame, also played at AJ&G Park that summer. The Nationals won a shutout but were impressed with the way Superintendent Samuel Lucas took care of the Gloversville grounds.

The JAGS folded as a baseball franchise in 1908. The park then became home to the Danforth Baseball Association over the next decade.

Charles Albert "Chief" Bender, a Hall of Fame pitcher and a member of the Chippewa nation, played at the Gloversville field in 1913, two days after his team, the Philadelphia Athletics, won the World Series. Bender won 212 games in his career, and some say he was the first to pitch the "slider." In 1916, Gloversville High School started playing baseball at the Harrison Street field.

Railroad Bows Out

In 1918, the FJ&G Railroad, citing declining use of AJ&G Park, gave up its lease on the property. The Parkhurst family stepped in and bought the facility, naming it Parkhurst Field. Edward S. Parkhurst headed a textile factory that made wool substitutes adjacent to the ball field. Parkhurst had been mayor of Gloversville from 1900 to 1902.

Parkhurst Field hosted regional ball teams through the 1940s. Local baseball legend George Burns, who played for the New York Giants, Philadelphia Athletics and Cincinnati Reds, came to Parkhurst Field with the Reds in 1923 to play a game against the local Elks team. When Burns retired from baseball, he moved to Gloversville.

Gloversville Little League

The Parkhurst family allowed the newly formed Gloversville Little League to begin playing at the field in 1955. Little League bought the ballpark in 1992.

A small museum at the field documents what Gloversville Little League President David Karpinski calls one of the oldest Little League grounds in the nation.

Karpinski said that funds are being collected and work has begun upgrading the infrastructure of the park. "We would like to work with the Baseball Hall of Fame in Cooperstown and baseball/railroad history buffs to get this place on the map as it was lost to history for a long time."

Karpinski added it's hoped to light the field eventually so it can be used three seasons and accommodate other sporting events.

Chapter 21

Life at the Children's Home

A group of concerned women started a home for needy children in Amsterdam in 1883. When first opened, four children were taken in, but the numbers grew rapidly.

In 1896, a dormitory-style Children's Home was built at 77 Guy Park Avenue and then enlarged in 1909. Money was donated by community leaders, including carpet industry executive Stephen Sanford.

Shirley Spurles Baroody remembered the day in the 1940s when her parents, migrant farm workers, were declared unfit—"whatever that meant at the time."

One older brother went to live with relatives. Shirley, about four years old, another older brother and an older sister were put into a Gloversville police car and taken to the Children's Home in Amsterdam. Baroody lived at the Guy Park Avenue facility for eleven years.

"The decision on where we were placed depended on who had the openings," said Baroody, who moved to Greensboro, North Carolina, as an adult. The Catholic Sisters of the Resurrection also operated a home for children on Market Street in Amsterdam.

"Three matrons took care of us, which was just amazing given the mechanics of caring for fifty children day in and day out," Baroody said.

The matrons in Baroody's day were Elizabeth Trenham, Genevieve Hopkins and Clara Hall, the last being Baroody's favorite "because she would read to us."

Trenham was a matron for forty-five years, retiring as supervisor in 1956, a year before the institution closed. The board of directors of the home described Trenham as "a real mother to hundreds of children."

Amsterdam's Children's Home, located at 77 Guy Park Avenue, closed in 1957. *Montgomery County Department of History and Archives.*

The children attended public school and went to Sunday school at the then First Methodist Church on Division Street. Otherwise they led a regimented life behind a fence and tulip garden and inside the walls of the Children's Home.

Girls and boys lived on separate sides of the building, getting together for meals. The children helped clean up after dinner. Each Saturday, laundry arrived with one clean dress for each girl for the week. Baths were twice a week. Children lined up for meals and even to brush their teeth.

The matrons emphasized good manners—boys and girls stood when an adult came into the room. Baroody remembered a few spankings but said she was not abused. She said living in the Children's Home "probably saved my life and guided me to better things."

My sister Arlene Cudmore worked at the Children's Home one summer when she was home from college, and I sometimes went to work with her. I remember being vaguely afraid of some of the children and the matrons when we were at the home, but nothing bad actually happened.

The older residents, Baroody recalled, were granted the privilege of leaving the building, some of the girls even going on a trip with the matrons to New York City.

Younger children spent many hours in the playroom sitting on wooden boxes that contained each child's possessions. Baroody said, "I cannot tell you how many hours I sat on that box while somebody taught us to knit or embroider, very quiet activities."

In December, the matrons asked each child for a list of three things wanted for Christmas. Baroody recalled getting paper dolls and white socks. The women's clubs of Amsterdam put on a Christmas party every year. Women from the then Forest Avenue Methodist Church did sewing for the residents.

The Children's Home had twenty-three residents when it closed at the end of the summer of 1957. Lack of both trained staff and children were cited. It was reported that twenty similar facilities closed that year around the state. Needy children were being placed instead in individual foster homes. The Amsterdam building was eventually torn down.

Baroody and her sister were sent back to their mother, then living in Schenectady. Their mother had visited "a few times," but there was no continual relationship with the girls, who were now teenagers.

"I think I was in shock for years, going from an institutional life where every minute of my life was guided and told what to do and then suddenly having tremendous freedoms," Baroody said. "Just staying outside whenever I wanted was a great joy to me."

What was the board of the children's home still exists as the Children's Aid Association of Montgomery County. In 2012, the Children's Aid Society contributed money to Liberty for a playground to be used by children, including those with developmental disabilities. In 2013, the association contributed money to help with children's activities at the new Walter Elwood Museum on Church Street.

Chapter 22

The Golf Course with a View

The first golf course built in the Amsterdam area was the private Antlers Country Club, opened in 1901 on land in Fort Johnson and Tribes Hill off Route 5. Today, the facility is the Rolling Hills Golf Course.

A ninety-acre site for the course was selected in 1900 by a moneyed group of business and professional men. We know the area as Fort Johnson, but in an era of lingering anti-British sentiment, the community then was called Akin, the name of a prominent local family. The Johnsons had fought on the British side during the American Revolution.

Historian Hugh Donlon said the land included part of the estate of Ethan Akin, the Lepper and Norton farms and other properties. To keep prices from rising, the land was purchased without indication that a golf course was the purpose.

Landscaping by Boston architect Frank M. Blaisdell began that year. Blaisdell also sketched the original clubhouse.

The clubhouse was built in 1901 with a spectacular view of the Mohawk Valley from its large porch or veranda. The first competition at the Antlers was on October 5 that year when the Antlers team defeated the Cayaduttas of Gloversville. C.D. Stewart had the winning score of eighty-seven for eighteen holes.

The first full season at the country club was in 1902. At the opening reception in June, Minch's Orchestra played for dancing, and the Thirteenth Brigade Band entertained on the lawn. The season ended with a ladies tournament in October. Laura Yund won the golf prize and Louise

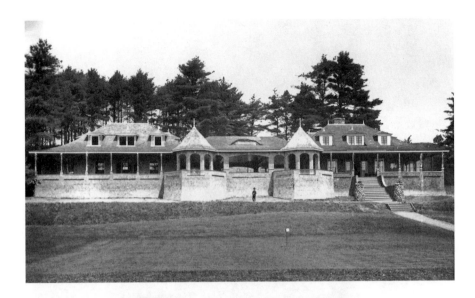

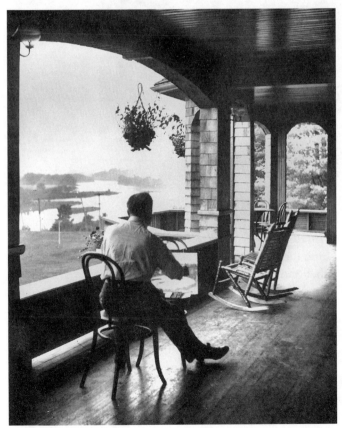

Above: The original Antlers Country Club in Fort Johnson had a commanding view of the Mohawk Valley. *Montgomery County Department of History and Archives.*

Left: View of the Mohawk Valley from the porch of the Antlers. *Montgomery County Department of History and Archives.*

Interior view at the Antlers Country Club. *Montgomery County Department of History and Archives.*

Taylor was tops in ping-pong. An annex to the clubhouse opened in 1904. Shakespeare's *As You Like It* was performed at the Antlers that year. Company H of the National Guard camped at the golf course in 1913.

The Antlers became a center for social activity among Amsterdam area mill owners and other movers and shakers. Holidays such as the Fourth of July were celebrated at the club. Family participation was encouraged, and minimum monthly expenditures for food and drink were required. The organization's charter assured members with daughters interested in marriage that the club was open only to "eligible males of the county over 21 and of approved character."

New York governor Al Smith visited the course in 1923. After a dinner of lobster and chicken, Governor Smith gave a speech in which he complained about the paperwork he had to deal with at his Albany office and then

praised the Antlers, which he called "a real golf course." Smith said, "The company is congenial and everything is lovely."

EDWARD HEATH

Born in 1888, Amsterdam native and pioneer aviator Edward B. Heath flew his first airplane at the Antlers golf course in 1910. The machine was built at the Johnson Machine Shop on Cedar Street in Amsterdam with the help of Heath's uncle and cousin, Chester and Frank Johnson.

Heath moved to Chicago where he started a company that made airplane parts in World War I. He won trophies in air races and manufactured the Heath Parasol, an ultralight airplane that he marketed as a kit. He also developed a plane called the Baby Bullet.

Heath died while testing a new airplane in 1931. The company he founded—Heathkit—became better known when it changed from making airplane kits to manufacturing electronic kits.

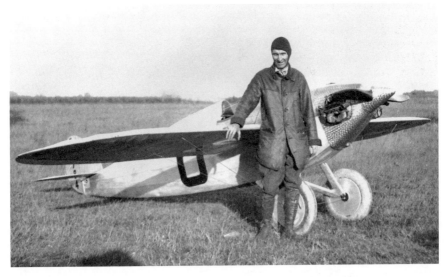

Amsterdam native and aviation pioneer Edward Heath with his Baby Bullet plane. Heath tested his first aircraft at the Antlers golf course. *Montgomery County Department of History and Archives.*

FIRE

On May 6, 1965, Antlers golf course neighbor Mrs. Ray Smith was putting out milk bottles at her home when she heard a strange sound, which she realized was the burglar alarm at the golf course. She then saw that the clubhouse was on fire and alerted the Fort Johnson fire department.

The beautiful old clubhouse burned to the ground. The club newsletter—edited by George Gill—reported, "It seems that for many years, talk around the club, at one time or another, has been about the possibility of a fire, and the pros and cons of what could and would be done if it ever happened. Well, it has happened, and I think that every person who went up the next day to see the ruins all felt that a little something had been taken away, something that will be hard to replace."

Donlon wrote, "The replacement made a year later was smaller and lacked the spacious veranda that had contributed so much to summer social life of affluent Amsterdamians for 60 years."

Chapter 23

An Iconic Tavern

The War on Booze

Amsterdam has been called the city of hills, mills and grills. The hills are still there, but the mills and grills are fewer in number.

In the early twentieth century, one of the most iconic Amsterdam taverns was O'Shaughnessy's. Located at East Main and Eagle Streets in a building no longer there, O'Shaughnessy's patrons included actor Kirk Douglas's father, Harry Demsky, and my grandfather, Harry Cudmore. My grandparents lived at 36 Eagle Street; the Demskys lived at 46 Eagle. My grandmother too enjoyed her beer, and my father would be sent to the tavern to get a growler of suds for his mother at Shaughn's back door.

Douglas wrote in his autobiography, *The Ragman's Son*, that his father, a Jewish ragman and legendary strong man, would stop at O'Shaughnessy's coming home from his route.

O'Shaughnessy's was owned by Amsterdam native Shawn Duffy's grandfather Martin J. O'Shaughnessy in the early 1900s. Duffy now lives in Lake St. Louis, Missouri.

Prohibition in 1920 closed the taverns, at least officially. An *Albany Evening Journal* story from 1926 reports a Martin Shaughnessy of Amsterdam was charged with selling beer.

Duffy wrote, "I guess it is a bit surprising that the bar survived Prohibition as so many did not. My mom, Mary O'Shaughnessy Duffy, told me that she used to help make bathtub gin when she was around ten, actually in the bathtub. Her brother Martin Junior sold the moonshine off the back porch to make ends meet during these hard times.

"Martin Junior had polio and was confined to a wheel chair. I always wondered if the coppers kind of turned their heads to not see a paralyzed person selling illegal moonshine off the back porch to help an old Irish tavern survive during the hard Prohibition times. I guess at this point we will never know, will we?"

Duffy doesn't remember Martin Sr. or Martin Jr. but recalls when his uncle Edward was running the saloon. At that time, the "O" was dropped from the tavern's name, and it was called Shaughnessy's.

A Useful Ice Crusher

The family nickname for Edward was Eb, while others called him Midge. Duffy wrote, "Eb was also known as KO because even though he was slight in stature (around 4 foot 5 inches or so), he did have a baseball bat which he used as an ice crusher. From what I understand he used it more than once on people who got too rowdy in the bar.

"The story was that if someone got out of line, Eb would grab his ice crusher bat out of the ice bin, jump up on the bar and take a good swing at whoever was out of line, including Harry Demsky."

When Duffy was young, he visited his grandmother, Rose Mullarkey O'Shaughnessy, who lived in an apartment house next to the tavern. The youngster was allowed to play shuffleboard at the bar for free. Rose died in 1961 and Eb in 1973.

Duffy said, "The bar also had one of the first color TVs in the area, so it brought in a big crowd on football Sunday. Looking back on it from today, it was pretty small, the color was pretty bad and it probably cost a small fortune."

The War on Booze

"I can remember my Dad telling stories of him and buddies running illegal liquor from Johnstown into Amsterdam during Prohibition," wrote a reader who only identified himself as Ralph. "Would you be able to dig up more information and details on this seldom talked about occupation?"

Historian Hugh Donlon wrote, "Amsterdam rum runners regularly hit the approved back roads toward Hamilton County and through the

Adirondacks to provide supposedly discerning customers with supposedly genuine Canadian products."

Bootleggers may have used a long-gone private airfield on Route 67 in the town of Amsterdam. Residents reported nights when lighted barrels would appear along the runway, and a plane would land, presumably carrying alcoholic beverages.

In December 1922 a large raid took place on Reid Street in Amsterdam. Federal agents seized fifty cases of beer, four gallons of whiskey, five quarts of gin and fifteen quarts of what was described as alcohol. Agents destroyed twenty gallons of whiskey. One man was charged.

Five days later, federal agents seized a horse and sleigh in Amsterdam allegedly being used to transport fifty gallons of wine in casks. As is the case with drug raids today, testing was to be done to ensure the liquid seized really was wine. Two grocery store proprietors loading the sleigh were charged with "illegally possessing and transporting intoxicants."

A story from October 1928 indicated that proof of operating a speakeasy came when an undercover officer was able to buy an alcoholic drink. Federal agents bought such a beverage at 29 Schuyler Street in Amsterdam and then arrested two men. Arrests came after a brief struggle in which one suspect sustained a badly discolored eye.

Bowler's Brewery on West Main Street, established in 1889, was converted into the Chuctanunda Dyeing & Dressing Company during Prohibition. But Donlon wrote that the establishment continued to make products that smelled alcoholic, and federal agents raided with "crippling frequency."

Bail for violators of the anti-alcohol law was high—$1,000 or $2,000 per person—given that a dollar was worth much more back then. However, those charged usually were able to make bail and were released.

Chapter 24

The Little Red Mansion on the Hill

M y radio career began in early 1962 after an audition conducted by the late Philip J. Spencer Sr., who then managed Amsterdam's WCSS.

Amsterdam did not get its own radio station until 1948, when businessmen headed by former mayor Arthur Carter formed Community Service Broadcasting and started WCSS. Carter, elected to six terms as Amsterdam mayor, had been doing a program called Carter's Comments on WSNY radio in Schenectady.

The Amsterdam station was housed in a new building on Midline Road adjacent to its radio tower. Carter and several local business leaders operated the station until 1953.

Walter T. Gaines took the helm then, and much entertainment and controversy ensued. Longtime morning host Lloyd Smith recalled that Gaines started calling the WCSS building, which was red at the time, the "little red mansion on the hill."

Today the building is home to an accounting firm, Spagnola & Spagnola. The structure is no longer red but has a white stone front and gray sides. The WCSS studios are now located at the city's Riverfront Center.

Smith recalled, "The 1950s disc jockeys would leave the control room windows open in summer—no air conditioning yet—and invite cars to toot the horn when they went by." It was common to hear a car horn beep right in the middle of a live commercial or the news.

Gaines left the Amsterdam station, and Phil Spencer came in to manage WCSS in 1956. Spencer ultimately bought the station.

In 1962, Spencer wanted a local high school student to work Sundays. Auditions took place at the "little red mansion" in what was then Studio A, today the office of Larry Spagnola. The 1962 audition winner was senior Steve Ferris. A junior, I came in second.

A few days later, WCSS program director Carl Bahn called. Ferris had turned down this opportunity for fame and fortune, and Bahn asked did I want the job. Of course I did. Ferris, by the way, became an attorney.

RADIO PERSONALITIES

Working at WCSS introduced me to talented and colorful individuals. I was announcer and board operator as Dean Dale and Cuzzy Barone provided live music. In my nasal voice, I introduced country music performer Dusty Miller.

Miller, whose real name was Elmer Rossi, always had a day job and a country music band—Dusty Miller and his Famous Colorado Wranglers. He took "Dusty" from a Roy Rogers song and "Miller" was the name of a company where he bought his Western duds.

"I like country music because it shows life as it is," Dusty once said. Dusty died in 1997 and was buried in his elaborate and beautiful Western clothes. He was affectionately known as "the little man with the big hat."

The talented Bill Pope had come to WCSS after a brief stint starting Amsterdam's other radio station WAFS in 1961. WAFS has morphed into WVTL AM and FM, and it's where I got back on the radio airwaves in 2004.

In 1962, Bill Pope was more than a cut above the rest of us in talent, and I copied everything he did. After starting as a sports reporter at WGY in 1944, Pope went on to be one of the most popular disc jockeys in Albany in the 1950s. On his WABY Saturday show, Pope began featuring rhythm-and-blues records to appeal to Albany's African Americans. White teens also were attracted by the music that came to be called rock-and-roll.

Making a gag out of his baldness, the Schenectady native became Curly Bill. Even though he was in his forties, Pope had such rapport with young people that he was known as Mr. Teenager.

When Pope moved to Amsterdam in 1961, he built a new following in a thirty-seven-year career as a big band disc jockey, talk host and promoter of sports and worthwhile causes. Pope nurtured broadcast newcomers who came through the doors of WCSS and met the bald-headed man who didn't see very well but who had this great gift of gab.

Phil Spencer said Pope never let his vision problems slow him down, "I would drive Bill downtown and park behind Bosco Greco's gas station opposite the post office. Bill and I were the only salesmen. I'd work one side of the street. He did the other. We'd meet in the afternoon, and I'd take him back to the station where he did his Rolling Home Show." Bill Pope died in 2002.

A Polish Star

Back in the summer of 1962 at WCSS, another one of my assignments was to read the English version of commercials on the nightly Polka Party hosted by former Polish freedom fighter and then beer distributor Richard Bartyzel. Bartyzel entertained and read the commercials in Polish.

Previously, I had been the announcer doing English commercials on Leonard Hartvigas's Sunday Lithuanian Hour. While Hartvigas was popular, Bartyzel was a star. I sometimes walked to work. If Bartyzel was on the air, I heard polka music wafting from houses along the way. Bartyzel had professionally produced jingles sung in Polish.

Bartyzel was born in Lodz, Poland, in 1922 and was a Polish Army veteran under the British Command in World War II. He died in 2012.

My Boyfriend's Back

My days at WCSS ended after the summer of 1963, when I headed off to Boston University. Although Phil Spencer never fired me, he also didn't hire me during future summer vacations, and I don't blame him.

WCSS was not a rock station, but I insisted on slipping in rock music. It made me popular with my high school peers. The Angels came out with the song "My Boyfriend's Back" in 1963. I was playing their record on the air when Phil came into the studio.

"Do you like that song?" he asked. When I told him I liked it very much, he replied, "Then take it home. I don't ever want to hear it again."

Phil Spencer originally was named Phil Spalletta. He was born on Long Island, where he became a lifelong fan of the then Brooklyn Dodgers. Early in his career, Spencer did play-by-play of Gloversville Glovers baseball

games for WENT radio in 1950. In 1952, he married Frances Lomanto, and they had two boys, Joseph and Philip.

Their son Joe Spencer was in the middle of a promising career in ABC network television news when he died in a helicopter crash while on his way to cover a meatpackers' strike in Minnesota in 1986. Eulogies were delivered at the Amsterdam funeral by ABC news anchor Peter Jennings and rising talk show personality Bill O'Reilly.

Phil Spencer Sr., who also served as town of Amsterdam supervisor, sold WCSS not long after his son's death and in later years pursued his interest in Dodgers baseball at his winter home in Florida. He died in 2004.

WENT,

Where Everyone Naturally Tunes

When severe thunderstorm winds took down most of WENT radio's fifty-nine-year old, 184-foot transmitting tower on Harrison Street Extension in the town of Johnstown on May 31, 2002, the phone calls started.

"I was glad no one was hurt," said Jack Scott, president and general manager of Whitney Broadcasting, which has owned the Gloversville-Johnstown radio station since 1986. The falling tower missed the station's nearby transmitter and studio buildings. Twisted and mangled steel lay like a snake around the stub of the tower.

Those calling on the phone missed their WENT. Some callers even offered financial help. Within two days, station engineer Lloyd Smith, who at the time was still host of the morning show on Amsterdam's WCSS, rigged a temporary system that enabled WENT to return to the air on reduced power. A new tower was in place by the end of June.

Radio was wartime America's dominant in-home entertainment medium when Plattsburgh radio station owner George Bissell founded Sacandaga Broadcasting Company and put WENT on the air on July 1, 1944. WENT, at 1340 AM, is the oldest radio station in Fulton and Montgomery Counties.

Licensed to Gloversville and Johnstown, WENT's main studios were originally at 8 Fulton Street at the downtown Gloversville Four Corners. There was a studio in Johnstown in the early days where George Hornidge did a program of community news called "Johnstown USA."

From its beginning until 1986, WENT was affiliated with the CBS Radio Network, which provided popular programs like Arthur Godfrey and Ma

Perkins in the 1940s and 1950s. Early on, the station was also affiliated with the Mutual Broadcasting System.

King Owen did a morning show on WENT in the early 1950s, mixing live piano music with his own stories. Owen had played the organ for radio shows in New York City. Owen was from Broadalbin, and his real name was Avery Clizbe. His wife was WENT's bookkeeper.

In the early 1950s, engineers played records at WENT's transmitter site on Harrison Street Extension for the announcers in Gloversville. Announcers had to pick music selections a day ahead and during their shows pressed a buzzer to alert the engineer to start the music.

Another popular WENT program was the country band Pals of the Saddle. Frank Lopuch, an IRS employee from Amsterdam during the day, and his brother Steve Lopuch headed the band. Steve Lopuch wrote some songs for prominent polka bandleader Jimmy Sturr.

In 1955, the radio station was sold to WENT Broadcasting, initially headed by Arthur Lloyd, who was succeeded within a year by Joseph Tobin. Originally from the Boston area, Tobin had been an announcer at WMCA in New York City and was a network announcer on the Kate Smith Show. At WENT, Tobin did the morning show. The station's studios moved from downtown Gloversville to the transmitter site in 1963.

Popular personalities of the era included newspaper reporter and broadcaster Sam Zurlo and disc jockeys Dick Brown, Bob Waite and Hank Kinney. Kinney was a singer who did an afternoon show on WENT.

In 1975, WENT was purchased by Dean Broadcasting, headed by Richard Ruby of Ruby and Quiri Furniture and Larry Peck. Peck recalled that Ruby's dad had been a regular guest on Joe Tobin's morning show.

Peck is a native son. His family developed nearby Peck's Lake for camping and fishing. As a young man, Peck worked for Joe Tobin at WENT. From 1960 to 1970, Peck was at WABY radio in Albany but came back to Fulton County and a position with Coca-Cola before buying WENT in 1975. Peck and Ruby sold WENT to Jack Scott and Whitney Broadcasting in 1986.

Peck recalled WENT weatherman James Chambers who studied meteorology on his own and offered his forecasts to local businesses. Chambers always carried an umbrella and began his reports by saying: "The forecast for Gloversville, Johnstown and vie-cinity." Chambers did his broadcasts from his own office, and the WENT announcers frequently had to try to raise Chambers several times before the sometimes-sleeping weatherman began his reports, which aired from the mid-1950s to the mid-1970s.

Robert "Saxy" Marshall did sports from the 1950s through the 1970s on WENT. Marshall owned Pedrick's Restaurant in Gloversville. According to novelist Richard Russo's memoir *Elsewhere*, Russo and his mother stopped at Pedrick's after shopping trips. The novelist wrote that Pedrick's was one of the few air-conditioned establishments of his youth.

Marshall had a band and was a faithful attendee at local sporting events. Like Chambers, Marshall favored unusual pronunciations, saying "Shenandoah" when referring to the high school at "Shenendehowa."

When Jack Scott bought WENT in 1986, one of the first things he intended to do was to drop the station's birthday announcements. He reconsidered that idea when the sales manager explained how popular the feature was with the audience and advertisers.

Scott's radio career began in 1970 at a country music station in Connecticut. He was a news anchor, sports anchor and talk host at WTNH television in New Haven. In 1976, he moved to California and worked in radio. He and his family wanted to move back to the Northeast in the 1980s, and when WENT became available, he purchased the station.

No one can say for sure, but it could be that the station call letters mirror a marketing slogan printed on early station brochures—Where Everyone Naturally Tunes.

Chapter 26

Hagaman, Manny's Corners and Amsterdam

The year Joseph Hagaman founded the Montgomery County community that bears his name is traditionally cited as 1777. However, historians Kelly Farquhar and Scott Haefner in their book *Amsterdam* report that Hagaman likely settled there at the end of the American Revolution in 1783.

Hagaman was from Dutchess County and of Dutch descent. One story is that he was going to locate near the confluence of the North Chuctanunda Creek and Mohawk River, the present site of the city of Amsterdam. Leaving a load of stone to mark his claim, Hagaman went back to Dutchess County to fetch his family.

When Hagaman returned, Albert Vedder was occupying the land in question. Vedder built a sawmill and gristmill on the lower Chuctanunda Creek, a settlement called Vedder's Mills.

Hagaman then went up the creek several miles and bought four hundred acres of land. He too built a sawmill and gristmill; the settlement was known as Hagaman's Mills.

MANNY'S CORNERS

In 1792, the first Presbyterian Church was organized at Manny's Corners, now the intersection of Route 67 and Truax Road in the town of Amsterdam, close to Hagaman. Four Revolutionary War soldiers are said to be buried in

the cemetery there. Manny's Corners was named for Gabriel Manny, who was born in 1740 in New York City.

In 1793, four townships were created in the area: Johnstown, Broadalbin, Mayfield and Amsterdam. In 1794, the Vedder settlement was renamed Veddersburg. In 1798, an estimated 275 people lived in the town of Amsterdam, which included the hamlets of Veddersburg, Manny's Corners and Hagaman's Mills.

Manny's son—Gabriel Manny Jr.—moved down the hill and operated the Manny Road House on the north side of what is now East Main Street or Route 5 in Amsterdam. The tavern and inn on the Mohawk Turnpike served travelers between 1795 and 1840.

The Pawling name looms large in Hagaman. Kingston native and Revolutionary War veteran Captain Henry Pawling, who had been stationed in Schenectady, moved to land just north of Hagaman in the 1790s.

GROWTH SPURT

The 1800 census showed a thousand people in the town of Amsterdam. In 1802, a visitor to Veddersburg noted four gristmills, two sawmills, two iron mills and a forge. In 1804 or 1808, the name of the hamlet of Veddersburg was changed to Amsterdam. The elder Gabriel Manny died in 1808.

Henry Pawling's son Levi married Jane Hagaman, a daughter of Joseph Hagaman in 1805. They had eleven children.

The 1810 census reported that 3,000 people lived in the town of Amsterdam. In 1813, the hamlet of Amsterdam—the settlement on the Mohawk River founded by Albert Vedder—had an estimated 150 people.

Joseph Hagaman died in 1817. The hamlet of Amsterdam became a village in 1830. Vedder was still alive in 1833, receiving a state military pension at the age of seventy-three.

There is an old cemetery off Pawling Street behind Cronies Restaurant in Hagaman. Hagamans, Pawlings and others are buried there.

In the late 1830s, William Greene of Poughkeepsie rented four buildings in Hagaman's Mills and began making carpets. In the 1840s, Greene and a partner, John Sanford, moved their carpet making to Amsterdam, where the rug industry became the city's main employer.

One of Levi Pawling's sons, Henry Pawling, built the family's first knitting mill in Hagaman in 1843. More knitting mills followed.

The Presbyterian church at Manny's Corners burned in the 1880s. The village of Amsterdam became a city in 1885. Pawling Hall on Pawling Street in Hagaman was built in 1891. The building still serves as a community and government center.

The hamlet of Hagaman's Mills became the village of Hagaman in 1892. A trolley line from Hagaman to Amsterdam was built in 1901.

ARLENE AND TED MADEJ

Arlene Druziak Madej grew up near the site of the Manny Road House on Route 5 in Amsterdam's East End. In 1950, her family, the Druziaks, moved up the hill to Manny's Corners.

"The most interesting place was the one room schoolhouse which was next to one of the oldest cemeteries in the town," Madej wrote. "The school was taught by one teacher for all students from first to seventh grade."

Ted Madej, who married Arlene in 1954, went to the one-room school and said the oldest child had to serve as janitor, cleaning and keeping the fires going. The last class graduated in 1960.

Arlene Madej said that Manny's Corners boasted farms and businesses years ago: Raulen Brothers Dairy Farm, Johnson's Dairy Farm, an airport and Harmon's Ice Pond.

Later arrivals included Manny's Corners Garage, the Chanticleer Restaurant and Paul's Texaco Gas Station and Roadside Stand, operated by Arlene's father Paul Druziak.

She wrote, "Sometimes people would pay my father with chickens, eggs or garden produce. Gas was three gallons for one dollar. That's where I met my future husband who was our paper boy."

HAGAMAN HISTORICAL SOCIETY

The Hagaman Historical Society meets regularly at Pawling Hall. The society was founded by longtime village resident Merrill Dye in 2002. A native of Gloversville, Dye met his future wife, Anna, on a train in World War II. He was a pharmacist's mate in the navy, and she was a nurse from Gardner, Massachusetts.

Merrill, Anna and daughter Elizabeth moved to Northern Boulevard in Hagaman in 1948. Dye worked as a chemist at Iroquois Chemical, an Amsterdam plant that served the leather tanning industry.

He died in 2004 at the age of ninety-six. Dye said in 2003, "I owe my longevity to having a good wife and good doctors."

Queen Anne and St. Ann's

S aint Ann's Episcopal Church in Amsterdam traces its beginnings to events set in motion by Queen Anne of England over three hundred years ago on the American frontier.

Roman Catholic Jesuits from France came to the Mohawk Valley in the 1600s. Three of them were killed by Mohawks at Auriesville and are now Roman Catholic saints—Isaac Jogues, René Goupil and Jean de Lalande. A local Mohawk Roman Catholic, Kateri Tekakwitha, became a saint in 2012.

The Dutch colonized what we call New York State in the 1600s, but the English took control for the rest of the colonial period in 1674 after the Third Anglo-Dutch War.

Five leaders of the Mohawk nation asked the governor of colonial New York to get a message to Queen Anne that she be "a good mother" and send someone to teach religion in 1702. It was the first year of Anne's twelve-year reign.

The first Anglican priest arrived in the Mohawk Valley that year. In 1712, four Mohawk chiefs went to England, and the English decided to translate the Bible and Book of Common Prayer into the Mohawk language and build a chapel in America. Queen Anne died two years later.

The work Queen Anne authorized in the Mohawk Valley could be regarded as the Church of England's first organized missionary endeavor.

The Queen paid for the chapel that opened on October 25, 1712, inside Fort Hunter, named for the colonial governor and built at the intersection of the Schoharie Creek and Mohawk River. Queen Anne provided altar cloths, communion silver and prayer books for the twenty-four-foot square structure.

Mohawks and colonists who supported England were forced to relocate to Canada during the American Revolution. After the war, Queen Anne's Chapel was used sporadically. Historian W. Max Reid quoted a 1790 journal that reported that the chapel was in wretched condition. The chapel was demolished in 1820 and sold for $750 to make way for the Erie Canal.

PORT JACKSON

After the canal was built, a good place to be in the area was Port Jackson on the canal, now the South Side of Amsterdam. St. Ann's of Port Jackson, an Episcopal Church, was organized in 1835 and a church was built in 1837 on Center Street.

By 1848, however, St. Ann's was in decline and its rector, Reverend A.N. Littlejohn, wrote that if the parish had a future, it would be on the growing north side of the river in Amsterdam.

In a St. Ann's history, Reverend George DeMille said that in the 1840s, there was an influx of immigrants to Amsterdam from Yorkshire and Lancashire in England. These immigrants worked in the local mills and became parishioners at St. Ann's. Over the years there were Welsh speakers who were part of St. Ann's.

The present St. Ann's building was consecrated in 1851 on Division Street. It was expanded in 1888. Church member M. Annie Allen Trapnell said at the time, "The interior of the [expanded] church is indeed a fair place."

The scholarly rector of St. Ann's, Reverend W.H. Trapnell, was a city native, born in 1836, who taught school in several upstate cities. Trapnell courted Annie for many years. They married in 1872 when she was thirty-five, and he was sixty. They moved to Maryland, where the reverend died four months later.

A MUSICAL CONGREGATION

St. Ann's and Second Presbyterian in the nineteenth and twentieth centuries were the churches where many of Amsterdam's prominent citizens worshipped.

St. Ann's, in particular, was known for music. In 1876, Emily Devendorf, a church member, published an Easter Anthem that stated, "For the trumpet

shall sound and the dead shall be raised incorruptible." Emily's husband was G. Smith Devendorf. The Devendorfs had no children and lived at 40 Division Street near St. Ann's, where husband and wife were in the choir. G. Smith directed the group.

Among twentieth-century music directors were carpet mill executive Reginald Harris, who also led the Mohawk Mills Chorus, and Otto Miller, who conducted the Amsterdam Little Symphony in the 1950s. Reverend William Orr, who served as rector for twenty-six years until his death in 1961, played organ and piano, started a girls' choir and strengthened the men's choir.

MOHAWKS RETURN; A PRAYER TABLE

In 1984, St. Ann's of Amsterdam renewed ties with descendants of its original Mohawk Indian parishioners. Members of Tyendinaga parish among the Mohawks in Canada frequently exchange visits with the congregation of St. Ann's.

Reverend Neal Longe was appointed rector of St. Ann's in 2012. Jay Towne, in his book *Shhh! This Is God's House*, noted that Reverend Longe has established a prayer table outside the church building where Longe prays each Monday morning for the needs of people passing by.

Chapter 28

McClumpha's at Market and Main

M arket and Main was the best-known intersection in old Amsterdam in the days when Market Street continued as Bridge Street across the Mohawk River to the South Side.

My father sometimes used a mildly obscene phrase that had as its punch line a description of kissing a person's posterior at the corner of Market and Main. The crossroads was old Amsterdam's most public place, its Times Square.

At last report in 2013, the modern Web design firm Engines of Creation was the tenant at 2 East Main at the corner of Market. A few years before that, the space was occupied by Uniforms & More.

During the 1960s and later, the storefront's tenants included Mike's Submarine and Tony Brooks Music and Records Nook. Sometimes Tony's band would rehearse in the window.

AN AMSTERDAM INSTITUTION

From 1857 to 1957, 2 to 4 East Main Street was home to McClumpha's Grocery. According to historian Hugh Donlon, John H. McClumpha had taken over the grocery store in 1857 after serving as a clerk there.

In 1883, William Kirwin's Directory, published locally by the *Daily Democrat* newspaper, reported that John McClumpha Jr.'s grocery and

provisions store occupied that address. Old-timers said that carpet maker Stephen Sanford would stop by after the store closed at night to play cards with McClumpha.

Donlon devotes almost a full page in his 1980 *Annals of a Mill Town* history book to McClumpha's. There was a store cat that kept rodents in check and sometimes slept in the front window. Every fall, large pumpkins were displayed from a Perth farm operated by Squire McQueen.

Donlon wrote that McClumpha's catered to the wealthy carriage trade, first of the village then the city of Amsterdam: "There was a certain social distinction to trading at McClumpha's. The clerks were genial and helpful, one particularly impressive when he carried on conversations in several languages."

That clerk was Dr. Charles F. McClumpha, a Princeton graduate who had been the English department chair at the University of Minnesota. When he retired, Professor McClumpha, who never married, came home to manage the family store. The professor added prestige to the store and the Amsterdam community. He was one of the founders of the Montgomery County Historical Society in 1904, and his home on Church Street is currently owned by the Polish American Veterans.

The professor was one of the speakers during the annual meeting of Amsterdam's Board of Trade in 1908, "You will find no place in picturesque Europe or any other foreign country that satisfies the aesthetic sense in man as does this beautiful Mohawk Valley of ours." At that point, Professor McClumpha's speech was interrupted by loud applause, according to the minutes of the meeting.

CLOSING TIME

Alfred McClumpha closed the grocery's doors for the last time on August 9, 1957. He had worked forty-eight years in the family business but toward the end had been sidelined for months because of illness.

Antique furnishings at McClumpha's, such as coffee grinders, scales and sulfur matches, ended up at the Henry Ford Museum in Dearborn, Michigan. McClumpha's had the last hand-crank telephone in the city, still in use in 1957.

"The store itself disappeared before arrival of shopping carts and checkout era," Donlon wrote. "These would have offered a space problem. There just wasn't room for carts, sometimes not enough for the customers."

In a newspaper eulogy written when McClumpha's closed, Donlon remembered the store's deliverymen, such as Frank Adebahr, Bert Wells and "Whistling Pete" Martuscello. "Whistling Pete" was the father of Frank Martuscello, Amsterdam's mayor in 1957.

Trask Cigar

Next to McClumpha's for many years at 6 East Main Street was a Trask Cigar Store. The chain of smoke shops was based in Gloversville and included stores in that city, Little Falls and Utica.

Daily Gazette reported that the Amsterdam store was for sale in 1969. It had been operated by George Rogers and Harry Van Derbeck. Van Derbeck, former proprietor of the Van Dyke tea store in Amsterdam, was known for "homespun philosophy and wry humor."

PART III
Stories We Tell

Chapter 29

An Incredible Journey

A young Dutch barber-surgeon who lived in what we call Albany and what was then called Fort Orange was the first European to document a journey through the Mohawk Valley. His journal has added importance as it makes the first printed reference to the Iroquois confederacy of Indian nations.

In 1991, Charles Gehring and William Starna, originally from St. Johnsville, translated Harmen Meyndertsz van den Bogaert's journal, *A Journey into Mohawk and Oneida Country, 1634–1635*. The original Dutch manuscript is part of a collection of rare documents at the Huntington Library in California. Artist George O'Connor of Brooklyn was fascinated by the translation and published a graphic novel version in 2009, *Journey into Mohawk Country*.

Van den Bogaert and two other young men set out in December 1634 to find out why the Fort Orange fur trade had dropped off with Iroquois tribes to the west.

The Dutch had settled in the area where the Mohawk and Hudson rivers meet in 1614, six years before the Pilgrims landed in Massachusetts. The first upstate Dutch outpost there was Fort Nassau, followed by Fort Orange in 1624. The fur trade was key to the economics of the New Netherland colony.

The Mohawks, the closest of the Iroquois nations to Fort Orange, told the Dutch that the French were trading for furs west of Mohawk territory. Gehring said the Indians generally preferred Dutch trade goods because of their high quality compared to what was offered by the French.

The Dutch emissaries took an Indian path to what is now Schenectady, although there was no settlement there. They crossed to the north side of the Mohawk River and traveled west. They crossed back to the south side beyond the point where the Schoharie Creek enters the Mohawk. They then proceeded west into territory occupied by the Oneida Nation in the area of present-day Little Falls.

The travelers sometimes were in water to their knees in cold weather, sleeping without a fire. "It's a wonder they didn't freeze," Gehring said.

The trio visited several Indian castles, as the Dutch called them. These were stockade settlements containing longhouses, some of them two hundred feet in length. The structures were made of bent saplings, Gehring said, tied at the top and covered with bark. There were sleeping platforms along the sides, and cooking was done over fires in the center with a hole in the roof to let smoke escape. The smoke irritated the eyes of the travelers.

The trip was one of the first made by Dutch colonists to Mohawk villages. The Indians crowded around the travelers so closely that the Dutch said they could hardly find space to relieve themselves.

When the Dutchmen were leaving the first Indian settlement, the Mohawks asked them to show how their firearms worked. The travelers complied the first time but did not use their weapons after that. Van den Bogaert said they were afraid the Indians would see how long it took them to reload and be tempted to overpower the travelers and take the weapons. In 1634, the Indians did not possess firearms, although they would have them within six years.

The travelers returned to Fort Orange with gifts. One of the Dutchmen wanted to take home a captive bear offered by the Indians but was convinced to leave the animal behind.

Van den Bogaert eventually became commander of Fort Orange. But in 1648 he was embroiled in a sexual controversy. He was accused of having a sexual relationship with a male slave named Tobias. Van den Bogaert was charged with sodomy, a capital offense.

Van den Bogaert fled to Indian country. A bounty hunter caught up with him at an Oneida longhouse, and in an exchange of gunfire, the longhouse was set ablaze and destroyed. Van den Bogaert was taken back to Fort Orange to await the arrival of Peter Stuyvesant from New Amsterdam, what is now New York City, who wanted to be on hand for van den Bogaert's trial.

Van den Bogaert escaped again when a sheet of floating ice badly damaged the fort. However, he then drowned in the Hudson River. Ironically, the penalty for sodomy was drowning. Gehring said, "If you were to write all this in a novel it would seem too absurd."

And van den Bogaert could be an ancestor of actor Humphrey Bogart. The name "van den Bogaert" means from the orchard.

CHARLES GEHRING

Charles Gehring, a native of Fort Plain, is the director of the New Netherland Research Center sponsored by the New York State Library in Albany and the coeditor of numerous collections of original documents from Dutch New Netherland.

The center is responsible for translating the official records of the Dutch colony, promoting awareness of the Dutch role in American history and providing a center for research in New Netherlandic studies.

Gehring earned a PhD in Germanic linguistics from Indiana University with a concentration in Netherlandic studies. His dissertation was a linguistic investigation of the survival of the Dutch language in colonial New York.

He has been a fellow of the Holland Society of New York since 1979.

In 1994, Her Majesty Queen Beatrix of the Netherlands conferred on him a knighthood as officer in the Order of Orange-Nassau.

The work Gehring has done on New Netherland history was the inspiration for Russell Shorto's 2004 bestseller about Manhattan, *The Island at the Center of the World*.

Charles Gehring, director of the New Netherland Research Center in Albany. *Charles Gehring.*

Chapter 30

The Mohawk Indian Encampment

In June 1957, a group of Mohawk Indians occupied land near the Schoharie Creek on the south side of the Mohawk River and remained there until they were evicted by court order in the spring of 1958.

The settlers were led by Chief Standing Arrow, also known as Frank Johnson. The 1957 encampment was meant to repossess part of an eight-thousand-acre tract the Mohawks said was not included in land ceded to the U.S. government by the Iroquois Confederacy in the Fort Stanwix Treaty of 1784. Their land claim was based on a 1924 document from attorney E.A. Everett that also praised the governmental system of the Iroquois Confederacy, which included the Mohawks and other tribes.

According to historian Hugh Donlon, there was talk of three thousand Mohawks coming to the 1957 settlement from the Mohawk reservation on the Canadian border with northern New York.

That large influx never happened. However, the Mohawks along the Schoharie fought vigorously in court when charged with hunting without a license, for example, contending they did not need a state license to hunt on their own lands. The hunters ultimately paid a ten-dollar fine. Chief Standing Arrow was fined for operating a motor vehicle without a license, despite his contention that he did not need a state driver's license.

At first, landowner Elmer Buckman, a dairy farmer, did not object to the Mohawk encampment. He was quoted as saying the encampment on his land was all right as long as the Mohawks "did not make any trouble." But as time passed, Buckman retained an attorney to get his land back,

and the Mohawks expanded their settlement to land owned by farmer William Dufel.

The Mohawks built a longhouse and small dwelling units. The scene was a tourist attraction in the summer of 1957, visible from the Thruway Bridge over the Schoharie Creek. That ill-fated bridge collapsed thirty years later, killing ten people. During Tropical Storm Irene in 2011, a pickup truck driver died in the vicinity when his truck was overtaken by water from the overflowing creek.

Famous Visitor

In October 1957, four months after the Mohawk encampment began, world-renowned man of letters Edmund Wilson paid a visit to Chief Standing Arrow.

Wilson described the encounter in his 1959 book, *Apologies to the Iroquois*. Wilson found that Standing Arrow was part of an Iroquois nationalist movement with adherents at the Onondaga reservation in the Syracuse area and at reservations in northern New York and Canada. In the book, Wilson also reports on meetings with other Indian nationalists.

Descended from an Upstate New York family named Talcott, Wilson maintained a summer home at Talcottville, north of Utica in Lewis County between the Adirondacks and Tug Hill Plateau. He died in 1972.

Before going to the Mohawk encampment, Wilson met with reporters from the *Recorder* in Amsterdam, including historian Donlon. Wilson also gathered information from the county archivist.

When Wilson arrived, the chief was away, and his family not willing to communicate. On a second visit, Wilson knocked at the door and no one came. When the author was getting back in his car, Standing Arrow appeared in the doorway and waved to him.

Wilson said, "It was a characteristic of an Indian that, not being up and dressed, he should not shout that he would be out in a minute but should wait until he could present himself with dignity."

Inside, the hut was "small but not ill-kept." There was a landscape of a lake hanging on the wall, along with a feathered headdress and a rattle made from the shell of a snapping turtle. Wilson said Standing Arrow, a former chief from the St. Regis Reservation, was a charismatic figure.

Wilson wrote, "A Mohawk who disapproved of Standing Arrow told me that his eloquence in English—of which his command was imperfect—was nothing to his eloquence in Mohawk."

Although Wilson had heard unfavorable things about Standing Arrow, he was "won over" by the chief, saying, "He appealed to the imagination." Wilson said Standing Arrow's features reminded him of the young Napoleon, even though he had "a slight cast in one eye."

"He had also, as I could see, some of the qualities of the Mussolinian spellbinder," wrote Wilson.

Wilson learned that some of the men in the settlement were high steel workers who had labored that year on the Thruway Bridge over the Schoharie Creek. Most of them had gone back to Brooklyn after the summer construction season.

The Mohawks are excellent working on tall construction projects—walking on a narrow beam high in the air is something they do very well. Wilson's book includes "A Study of the Mohawks in High Steel," written by Joseph Mitchell in 1949, describing the lives led by Mohawks in New York City who worked on skyscraper construction.

EVICTION

Montgomery County sheriff Alton Dingman served the first eviction notices on the Mohawk settlement along the Schoharie Creek in January 1958. Since Chief Standing Arrow was not in camp at the time, his notice was nailed to the longhouse.

The winter was a tough one, and snow covered part of the encampment that housed some forty people at that point, according to a *Daily Gazette* report. Sheriff Dingman and two officers parked on Route 5-S and trudged through the snow to serve the legal papers at the settlement, located south of the highway. The Salvation Army had provided some assistance to the residents at Christmas in the form of food and clothing.

In March 1958, twenty-five people were reported still living at the Schoharie Creek Indian site. After a court hearing that month that resulted in another eviction order, some of the Mohawk huts were burned. The encampment ended soon after that. The Mohawks were offered land in the town of Fulton in Schoharie County as an alternative site in the area, but if there was a settlement there, it was short-lived.

Donlon wrote, "The Dufel corn fields between Fort Hunter and Auriesville were again in high-stalk production during the following summer."

A NEW SETTLEMENT

In September 1993, a group of traditional Mohawks moved into Kanatsiohareke, a settlement in Yosts west of Fonda on Route 5. Located on the north side of the river at the former site of the county adult home, Kanatsiohareke is a not-for-profit corporation that purchased the property from Montgomery County. The name of the settlement means the "place of the clean pot."

It is a place to which many American Indians and others travel to learn the Mohawk language and otherwise preserve native heritage. A Strawberry Festival is held in the summer, and the shop at the site sells Native American crafts.

Chief Thomas R. Porter (Sakokwenionkwas or "The One Who Wins") was the founder and is the spiritual leader of Kanatsiohareke. Porter is a member of the Bear Clan of the Mohawk Nation and a nephew of Frank Johnson, Chief Standing Arrow.

Chapter 31

The Sanfords and Hollywood

D irector George Cukor's 1938 movie *Holiday*, which starred Katharine Hepburn and Cary Grant, has three fictional characters based on members of the wealthy Sanford family of Amsterdam.

The family founded Sanford & Sons, the first of Amsterdam's two major carpet mills. The company merged with another firm to become Bigelow-Sanford in 1929. Bigelow-Sanford left Amsterdam in 1955.

Gertrude Sanford Legendre's *New York Times* obituary said the three children of John and Ethel Sanford—Gertrude, Laddie and Sarah Jane—were the inspiration for the 1929 Philip Barry stage play *Holiday*, which became the basis of the movie. Barry, a native of Rochester, also wrote the play *The Philadelphia Story*.

John Sanford inherited an estate worth an estimated $40 million when his father, Stephen Sanford, died in 1913. That was a tremendous amount of money at the time.

Gertrude, the youngest in the family, was born in 1902 in Aiken, South Carolina, but spent time growing up with her two siblings at the family's New York townhouse on East Seventy-second Street and their Amsterdam mansion on Church Street, later donated by the Sanfords for use as the city hall in 1932.

In the movie, the fictional wealthy family makes use of a fourth-floor playroom used by the children when they were young. Amsterdam's Sanford family also had a playroom on the third floor of the Amsterdam mansion.

According to the *Times*, "Gertrude Sanford was in her teens when she took a hunting trip to the Grand Tetons of Wyoming and shot her first elk. For years, she pursued big game in Africa, India, Iran and Indochina, and

Cary Grant and Katharine Hepburn starred in the 1938 film *Holiday*, loosely based on Amsterdam's Sanford family. *Kobal Collection at Art Resource NY.*

contributed rare specimens to museums." A portrait of her as a stunning young woman was painted by the Irish portrait artist Sir William Orpen in 1922. She married fellow explorer Sidney Legendre in 1929.

The movie character Linda Seton, played by Katharine Hepburn, is a strong-willed woman based on Gertrude Sanford. Hepburn was the understudy for the part when the play was produced on Broadway.

Debutante Spy

In World War II, Gertrude served in France with America's Office for Strategic Services, predecessor of the Central Intelligence Agency, until she was captured by the Germans.

The *Times* reported, "Held as a prisoner of war for six months, she escaped and went by train to Switzerland. The train stopped short of the border; as she dashed to the frontier, a German guard ordered her to halt or be shot. She continued, and reached the border."

In Switzerland, Gertrude had dinner with Allen Dulles, future head of the CIA, and told him the story of her captivity as a secretary transcribed the tale.

Her husband died in 1948, but Gertrude lived until 2000, passing on at age ninety-seven. She made her home at Medway, a plantation near Charleston, South Carolina, where she held a New Year's Eve costume ball for fifty years. She wrote two autobiographies, *The Sands Ceased to Run* (1947) and *The Time of My Life* (1987).

LADDIE AND SARAH JANE

Laddie Sanford usually went by that nickname, but he was officially named Stephen after his grandfather, who doted on the youngster. The *Holiday* character Ned Seton, portrayed by Lew Ayres, is loosely based on Laddie.

More a playboy than industrialist, Laddie was born in 1899 and became an international polo star. He married actress Mary Duncan in 1933.

A native of Virginia, Duncan performed on Broadway in the 1920s. Critics praised her work in the play *The Shanghai Gesture*, and she went to Hollywood. Her credits included *State's Attorney* (1932) with John Barrymore and *Morning Glory* (1933) with Katharine Hepburn. While making *Five and Ten*, she became friends with the film's lead, Marion Davies, who introduced her to Laddie Sanford after a polo match. Davies was the mistress of media tycoon William Randolph Hearst.

When Mary Duncan and Laddie Sanford married, she retired from acting, and they made their main home at the mansion Los Incas in Palm Beach, Florida. Mary reigned over Palm Beach society for fifty years, according to the *New York Times*. Her charitable work was extensive. She was friends with Rose Kennedy, who was a neighbor, and entertained the King and Queen of Jordan and the Duke and Duchess of Windsor. She and Laddie also hosted King Saud al Saud of Saudi Arabia at a dinner where, keeping with Muslim tradition, no alcohol was provided, and there was no smoking.

Laddie, who passed away in 1977, and Mary, who died in 1993, are both buried at Green Hill Cemetery in Amsterdam. The cemetery, listed on the

State and National Register of Historic Places, is adjacent to city hall, the former Sanford mansion.

The *Holiday* film character Julia Seton, played by Doris Nolan, is based on Sarah Jane Sanford. Named for her grandmother, Sarah Jane was married in Palm Beach Florida in an exclusive society wedding in 1937 to Signor Mario Pansa, an Italian diplomat in Mussolini's government who, like Sarah Jane's brother Laddie, was also a polo player.

The Pansas lived in Italy during World War II, but Sarah Jane was back in America in 1946 when Mario Pansa accidently drowned in a swimming accident near Rome. Sarah Jane died in 1985 and is buried at Green Hill Cemetery.

EXTRA SPECIAL FILM

University at Albany film history professor Rob Edelman, who lives in Amsterdam, said he regularly screens *Holiday* in his American film genres class, saying, "For me, this film always has been extra special. What makes it so, beyond its entertainment value and the star appeal of Katharine Hepburn, Cary Grant and the supporting cast, is its worldview.

"Put forth in *Holiday* is the idea that money isn't everything. What matters in life is to live as you see fit. Do not be a slave to the almighty dollar. Life is short. Live, have fun and keep the child alive within you."

Edelman said the 1938 George Cukor film is not the first film version of *Holiday*. "An earlier adaptation was released in 1930. Edward Everett Horton, who plays Professor Potter, is the only actor who appears in both." In the 1930 version, directed by Edward H. Griffith, Ann Harding plays Linda Seton, Monroe Owsley portrays Ned Seton and Mary Astor is Julia Seton.

Edelman is a contributing editor of Leonard Maltin's *Movie Guide* and does film commentary on WAMC radio.

Chapter 32

Rescued from the Depths

The explosion onboard the Russian submarine *Kursk* in August 2000 prompted an Amsterdam man to open up about his own rescue decades earlier from a stricken submarine. Hydrogen peroxide in a torpedo on the *Kursk* exploded, causing other warheads to detonate, sending the submarine to the bottom of the Barents Sea, north of Russia. All 188 sailors on board died. Their bodies and the submarine were recovered in 2001 by a Dutch underwater team.

Three days after the *Kursk* explosion, Donato Persico of Amsterdam was interviewed about submarine disasters by Lee Coleman for the *Daily Gazette*. "Dan" Persico had been aboard the USS *Squalus* in May 1939 when there was a valve failure and the boat sank 243 feet to the bottom of the Atlantic Ocean near Portsmouth, New Hampshire. The *Squalus* was new and was making test drives.

"This happened so fast, there was no chance for an alarm," Persico said. "We lost power and lost lights." The Amsterdam sailor was almost crushed by a torpedo.

Persico and other crew members closed watertight doors to prevent the entire submarine from flooding. As the submarine sank, twenty-nine sailors drowned. Survivors donned woolen submarine coats and tried to stay still and use as little oxygen as possible.

"It was cold and dark," Persico said. "I had goose bumps. I was scared." At twenty, he was the youngest man on board. Persico was among the last of thirty-three crew members rescued in multiple trips of a diving bell deployed

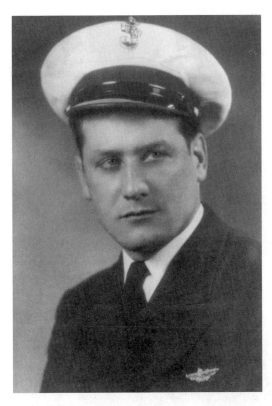

Submariner Donato Persico, among the last men rescued from the USS *Squalus* in 1939. *Felicia Persico.*

by the rescue ship *Falcon* on the surface.

"It was the best ride I had in my life, the ride in that bell," Persico said.

Persico said when the diving bell was about halfway up, there was a problem with the lifting cables. "They dropped us back to the bottom and pulled it in by hand with only one strand of cable. I was on the last trip and rode up with the captain [Oliver F. Naquin of New Orleans]."

Anne Persico Signoracci of Cohoes, Donato's sister, said as the rescue unfolded the family was kept informed by Amsterdam police officers who periodically stopped at the family home with updates. Signoracci said the experience gave her brother a new lease on life.

Persico's nephew Anthony E. Signoracci said, "Uncle Dan was quite a guy. He always had a sly smile on his face. I think it was because he cheated certain death. I think he saw death staring him in the face. My mother told me that when he came home, it was all about enjoying life. He was given a second chance so to speak."

The navy was able to raise the sunken *Squalus*. It was repaired and recommissioned as the *Sailfish* and was awarded nine battle stars in World War II.

After the rescue, Persico served with distinction aboard two other submarines in the Pacific. One of them, USS *Batfish*, sank three Japanese submarines in a period of seventy-six hours. Persico retired in 1956 as a chief torpedo man and recruiter and embarked on a career as a heavy equipment salesman for the L.B. Smith Co., covering the Capital Region.

He married Felicia Puglia of Amsterdam in 1973. They had met during a chance encounter between Persico and another sailor and Puglia and a

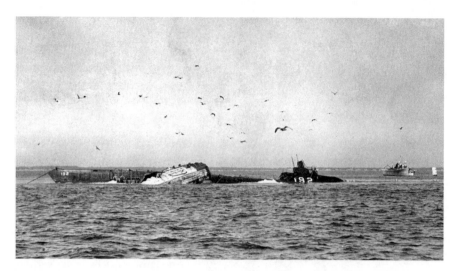

The USS *Squalus* after it was brought to the surface from the bottom of the ocean. *Felicia Persico.*

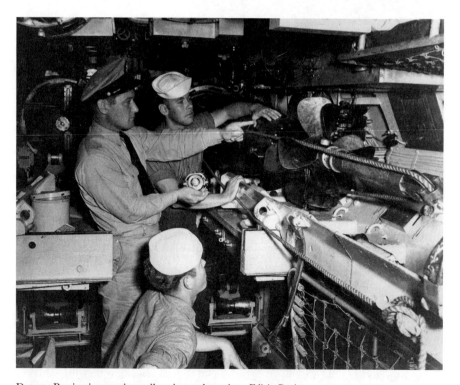

Donato Persico instructing sailors in a submarine. *Felicia Persico.*

girlfriend at the bar of the former Peter Stuyvesant Hotel in Amsterdam. After that meeting, they did not see each other for ten years. They married when Persico returned to Amsterdam permanently after his mother died. The couple had no children. Felicia also served in the military in the army and air force.

"He was my hero," Felicia Persico said. "A wonderful man, good sailor, a good husband."

Persico retired in the 1970s and made trips with Felicia to Florida during the winter months. They were active in a submariner veterans' organization. In September 2000, Persico was one of two *Squalus* survivors who shook hands with Navy Secretary Richard Danzig at a ceremony naming a navy destroyer for the man who organized the *Squalus* rescue, Charles "Swede" Momsen.

Persico died on January 26, 2001. Family and friends lobbied the city of Amsterdam for a memorial to honor him, and the intersection of Florida Avenue and Bridge Street on the South Side was named Persico Square that September.

Chapter 33

The Day We Bombed Fort Plain

J ust over three months before the United States entered World War II, the American military simulated an enemy attack on the airport off Route 5-S in Fort Plain. According to press accounts, forty-six soldiers and two officers were on the ground at Fort Plain's airport on Tuesday, August 26, 1941, having arrived the night before. They included members of an artillery regiment who would defend the airstrip against a simulated attack by six fighter planes and one bomber flying out of the airport in Windsor Locks, Connecticut. A passenger on the bomber was Lieutenant Robert Ardison of Fort Plain. Dynamite was used to simulate bomb impacts. Roads were closed off and spectators prohibited from the immediate area.

A flight of six P-40 fighters took off from a temporary airstrip concealed in a nearby apple orchard to fight the attacking planes. Military and Amsterdam city historian Robert Von Hasseln said that it is likely that Lieutenant Phillip Cochran was part of the fighter group in Fort Plain.

Pictures of the Fort Plain exercise were included in the December 1 edition of *Life* magazine, just a few days before America was attacked for real at Pearl Harbor. One of the photos shows a pilot reading in a barn who appears to be Cochran.

Von Hasseln said Cochran was the inspiration for "Colonel Flip Corkin" and "General Philerie" in Milt Caniff's cartoon strips *Terry and the Pirates* and *Steve Canyon*. In real life, Cochran was commander of a fighter group that flew in Burma in support of British and American Special Forces. Cochran

pioneered many innovative tactics including operating from temporary unimproved airfields.

"Perhaps he got the idea flying out of Fort Plain in 1941," von Hasseln said.

Fort Plain

Fort Plain itself was built in the late 1770s during the American Revolution. General George Washington visited the area in 1783. Most historians say the fort was on top of a hill off what is now Route 5-S west of the village, on property now owned by the Fort Plain Museum and Fort Plain Cemetery.

Fort Plain is a village within the town of Minden. Minden was created in 1798 by dividing the town of Canajoharie. The Village of Fort Plain prospered with the building of the Erie Canal and the West Shore Railroad in the nineteenth and early twentieth centuries. A limestone aqueduct carried the canal over the Otsquago Creek in Fort Plain. The aqueduct was destroyed during floods in 1981.

One of Montgomery County's first newspapers, the *Watchtower*, was published in Fort Plain in 1827. A toll bridge was constructed over the Mohawk River, linking Fort Plain and Nelliston. Tolls were lifted after 1857.

The Clock Building at Canal and Mohawk Streets, built in 1832, was originally a hotel called Montgomery Hall. The Fritcher Opera House was on River Street. Built in 1878, the building and Union Hotel next door burned in 1911.

The Clinton Liberal Institute relocated from Clinton to Fort Plain in 1879. The school had military instruction and two hundred students in its heyday, including Simon Lake, the inventor of the submarine. The institute was destroyed by fire in 1900.

A.J. Sneck operated an electrical goods shop at Canal and River streets in Fort Plain. An electrician who worked for Sneck, Julius Failing, brought electricity to Fort Plain and Nelliston. In the first half of the twentieth century, streets and sidewalks were paved and a storm sewer system was installed.

From 1898 to 1924, the Fort Plain Street Fair was a big event each September. County historian Kelly Yacobucci Farquhar wrote, "They had high divers, concerts, rides, baseball games and store vendors would set up booths on the streets. They had thousands of people coming." The event was not held during World War I.

Farquhar's book *Montgomery County* includes a picture showing her great-great-grandparents, Henry and Angelina (Smith) Baum, at the Fort Plain Street Fair in 1909. They are seated with an unidentified couple in an automobile, a newfangled contraption back then, in front of a painted country scene.

For more on Fort Plain, see the closing chapter on Mohawk Valley floods.

Chapter 34

Parking Lot Helped Propel the Wilson Family

When people shopped in downtown Amsterdam years ago and parking spaces were hard to find, a prime destination was the lot behind the East Main Street stores on Federal Street, between Church and Chuctanunda Streets.

The proprietor was Harrison B. Wilson. Wilson and other members of his family kept watch on the cars from inside a small shed. He'd brush the snow off your car and back it out if necessary. The small parking lot seemed to house an improbable number of cars.

Wilson, an African American, was born in Falmouth, Kentucky, said to be the youngest of thirteen children. Wilson's father was a farmer who had been a slave owned by a Confederate colonel. The elder Wilson fought first for the Confederacy and then for the Union and was freed after the Civil War.

Harrison Wilson came to Amsterdam in about 1910. His sister married a man named Goff who lived in the West End. Harrison's brother Albert also came to Amsterdam and established a moving business.

Harrison Wilson worked as a plasterer on construction projects, although racial discrimination kept him out of the plasterers union. Wilson later became a maintenance man for builder and landlord Thomas McGibbon.

The Fire

Wilson played a heroic role in saving people from a major fire in a downtown Amsterdam building owned by McGibbon. On April 6, 1943, a blaze destroyed the McGibbon Block at 72–76 East Main Street, at the time on the north side of East Main between Church and Liberty Streets.

The fire started after second-floor bowling alleys collapsed, trapping two female pinsetters, Norma Hopkins and Irene Lewis. Wilson was working in the bowling alley, and he and an unidentified man safely extricated the two girls. Wilson also helped other bowling alley pinsetters evacuate the building.

The bowling alleys fell into the first-floor Empire Super Market a half hour before the market's 6:00 p.m. closing. Meat manager Albert Smith, hit

Harrison Wilson led people to safety as fire destroyed the McGibbon block in downtown Amsterdam. *Montgomery County Department of History and Archives.*

on the shoulder by a falling timber, sustained the most severe injury. The falling debris apparently released flammable gas that ignited through short circuits in the electric system.

It was very windy and fire spread quickly. Help was summoned by Mayor Arthur Carter from other municipalities. Firefighters had to quickly douse fires that broke out on roofs of nearby buildings, even a blaze on the roof of St. Stanislaus Church on Reid Hill. In 1949, the new Tryon movie theater opened on the site of the McGibbon Block. The area is now part of the Riverfront Center, the downtown mall.

McGibbon's Will

Owner McGibbon collapsed at his Guy Park Avenue home when told of the fire in 1943, the second blaze in two years at that business block. McGibbon died later that year. He left the parking lot that he owned on Federal Street to Wilson.

Wilson and his wife, Marguerite, raised eight children. Marguerite's grandmother had taught at a one-room school in Kentucky. In Amsterdam, the Wilson family lived at various locations, including Cedar and Pine Streets. Marguerite died in 1960, and Harrison, a trustee of the city's A.M.E. Zion Church, died at age ninety-four in 1982. They are buried at Fairview Cemetery.

Three of their sons—Harrison Jr., Willis and Albert—played basketball for Amsterdam High School and in college.

All the Wilson children pursued substantial careers in health care, industry and education. Albert Wilson became an attorney in New York City and then an official with a major teachers' retirement fund. Edward Wilson was employed at Ford Motor Company in Detroit. Willis Wilson became associate director of the Extension Service in Washington, D.C. His son, Willis Wilson Jr. is head coach of the Texas A&M–Corpus Christi Islanders men's basketball team. Previously, he was head basketball coach at Rice University for sixteen seasons. Martha Wilson was a nurse in Texas; Virginia Wilson was a cancer researcher in Minnesota.

Harrison Wilson Jr. became president of Norfolk State University in Virginia, a post he held for twenty-two years. According to an article on Diverse, a higher education website, Harrison Jr. said his first job was shining shoes as a seven-year-old boy in Amsterdam. His mother, he said, told him about how he looked like his grandfather and that instilled pride in the young man.

Quarterback Russell Wilson of the Seattle Seahawks, great-grandson of Harrison Wilson of Amsterdam. *Seattle Seahawks.*

Harrison Jr.'s son, the late Harrison Wilson III, was a lawyer, and Harrison III's son Russell Wilson is pursuing a professional sports career. At last report, Russell Wilson was a National Football League quarterback playing for the Seattle Seahawks. According to *Seattle Times* reporter Bob Condotta, Russell Wilson is a football savant who lives the game twenty-four hours a day.

Harrison Jr.'s daughter April Wilson Woodard is a TV news anchor, reporter and personality who heads Favor Multi-Media. She previously reported for CBS and Black Entertainment Television.

Chapter 35
An Unforgettable Day

S am Vomero will never forget Monday, July 20, 1942, the day the New York Yankees and the carnival both came to Amsterdam.

The Yankees exhibition game against their farm team, the Rugmakers, on that date is remembered by many. But Vomero said that on the same day, the James E. Strates Shows arrived in Amsterdam, traveling on its own train of thirty cars.

Vomero, twelve years old and living on Morris Street in the East End, waited for the carnival train with a crowd of people at the old freight house Sunday night. Vomero gave up his vigil about 2:00 a.m. and returned to the freight house Monday morning after the train, including Strates's private railroad car, had finally arrived.

The carnival, sponsored by V.F.W. Post 55, set up at Karp's Park on Upper Church Street and featured Adele Nelson's "baseball playing elephants," a trapeze artist and what was called "America's best midway."

The Yankees arrived at 12:35 that afternoon when the crack New York Central train the Empire State Express made a special stop in the city, depositing Joe DiMaggio and his fellow Yankees in a sea of autograph-seeking fans. Police Chief Frank Kearns assigned a special detail of patrolmen to keep the crowd off the tracks.

There was a parade complete with the high school band and upper-floor office workers pitching ticker tape onto the Yankees. According to David Pietrusza's book, *Baseball's Canadian-American League*, DiMaggio and Lefty Gomez missed the team bus when it left the Hotel Thayer on Division

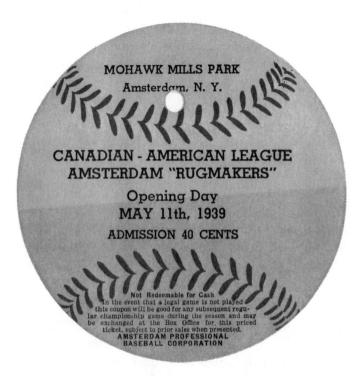

A 1939 Amsterdam Rugmakers ticket in the shape of a baseball. *Author's collection.*

Street. The two ballplayers were given a ride to Mohawk Mills Park by fan George Sandy for the 4:00 p.m. game. Sandy recalled that DiMaggio asked, "Where in hell are all the girls in this town?"

Incredibly, fire had destroyed the grandstand at Mohawk Mills Park eight days before the big game. Pietrusza wrote, "Hammers and saws replaced bats and balls at the site, and a miracle happened. By the time the Yankees arrived, not only had every barbecued seat been replaced, but the park's total capacity had been increased by 200 seats."

Joe DiMaggio hit a two-run homer over the 320-foot right field fence in the fourth. The game went to extra innings, and the Yankees won 9–5 in the tenth.

The New York City baseball writers were impressed with what Jack Smith of the *Daily News* called the "sheer love of baseball, enthusiasm and support" they found in Amsterdam. An illustration accompanying Smith's column showed a sign that was typical of Amsterdam that day, "Welcome Yanks. Closed for the afternoon."

A seven-year-old heart patient named Johnny Martuscello, wearing a Superman shirt, got to meet his idol, DiMaggio. "Even the hardened veterans who have played exhibition games from coast to coast were moved," Smith wrote.

Vomero was among the four thousand fans at the ballgame, and that night he walked to the carnival. The James E. Strates Shows returned the following year with a new featured performer, the Great Wilno. Wilno was shot from cannon over two Ferris wheels into a net. The stunt worked well in Amsterdam, but Vomero recalled reading that Wilno later died in Syracuse when he hit a Ferris wheel during a performance. Vomero said the Strates Shows can still be seen at the State Fair in Syracuse, but the carnival never came back to Amsterdam after 1943.

The Yankees returned to Mohawk Mills Park in 1949 and drew a crowd of 4,562, about 500 more than 1942. The 1949 Yankees, including Yogi Berra and Phil Rizzuto, beat the Rugmakers 9–2.

MOHAWK MILLS CONNECTION

Herbert Shuttleworth II, who later became head of Mohawk Carpets, was in charge of the Rugmakers baseball team in 1939. A scorecard from the 1939 Rugmakers season shows admission was forty cents, and the scorecard cost five cents. Years later, the park was renamed in honor of Shuttleworth, and he was inducted into the Amsterdam Baseball/Mohawks Baseball Hall of Fame in 2009, the year before he died. The Mohawks are a collegiate summer baseball team.

The late John Szkaradek tried to get into Mohawk Mills Park for free by finding baseballs that had been hit out of the park. If that didn't work, he and other youngsters resorted to peepholes in the park fence. Szkaradek recalled that Charlotte Snyder, who lived at Hawk and Church Streets, was at every game and rang a loud cowbell from time to time.

"There was one older gentleman," Szkaradek said, "who also attended all the games, and he circulated from the first and third base walkways to the seats. He generally called balls and strikes to help out the umpires.

"Probably one of the most popular good players for the team was Bunny Mick at center field. I believe a number of the players use to patronize Isabel's Restaurant on West Main Street. I remember Judge Robert Sise pitching against the Rugmakers while he played for the Gloversville team. My wife, Dolores, had an autographed baseball signed by Yogi Berra."

Virginia Dybas Czelusniak of Amsterdam used to go to the games. Czelusniak, who grew up on Crane Street, said she and her friends liked talking with the young ballplayers.

GLOVERSVILLE GLOVERS

The Gloversville Glovers also played in the Canadian-American League. Glovers Park needed work in 1937 when the Can-Am team started using the facility. Even though baseball had been played there as far back as 1898, the outfield was a muddy hayfield, and the original fences were snow fences. Lights were installed in 1940, and the park at the corner of Fifth Avenue and Route 30A was overhauled in 1948.

In 1950, an orange-and-black color scheme was adopted for the scoreboard. Major league manager Jack McKeon, who led the Florida Marlins to a World Series victory in 2003, was a catcher for the Glovers in 1950. The late area broadcaster Phil Spencer did play-by-play for Glovers' games on WENT radio that year.

The Glovers, a farm team for the former St. Louis Browns, played their last season in 1951. By then television coverage of major league baseball put a damper on the minor leagues.

Chapter 36

Death Rode on the Wings
of the Wind

T hree pioneer aviators, including a Gloversville native, died when their plane crashed into a buckwheat field near Rural Grove in the Montgomery County town of Root on January 8, 1928. Though out in the country, the crash site attracted thousands of gawkers.

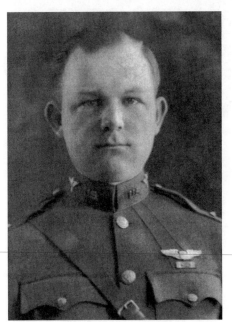

The Gloversville native who perished in the accident was Edward M. Pauley. Born in 1895, Pauley served on the ground in World War I in the motor transport corps. After the war, he became a civilian pilot and then rejoined the U.S. Army Flying Corps, earning the rank of captain. Pauley married Marion Howarth of Johnstown. They had no children. He was in the army reserves when he died.

Captain Edward Pauley, pioneer aviator and Gloversville native. *Frances Burnham.*

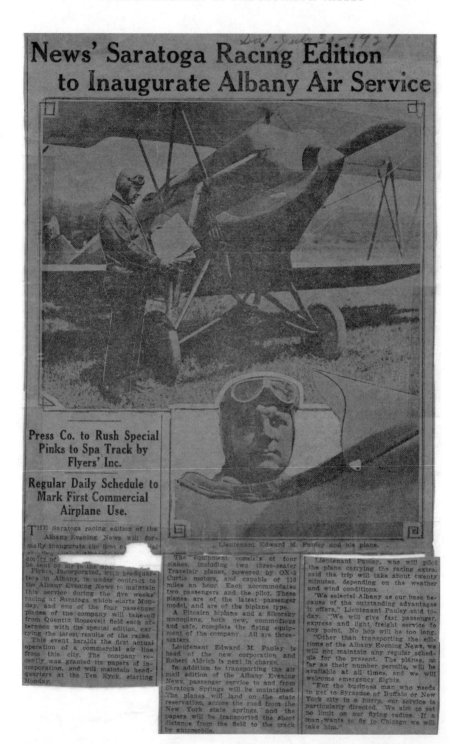

News' Saratoga Racing Edition to Inaugurate Albany Air Service

Sat. July 31, 1937

Press Co. to Rush Special Pinks to Spa Track by Flyers' Inc.

Regular Daily Schedule to Mark First Commercial Airplane Use.

THE Saratoga racing edition of the Albany Evening News will formally inaugurate the first commercial air line in this part of the state when copies of the paper are to be sent by air to the Spa. Flyers, Incorporated, with headquarters in Albany, is under contract to the Albany Evening News to maintain this service during the five weeks' racing at Saratoga which starts Monday, and one of the four passenger planes of the company will take off from Quentin Roosevelt field each afternoon with the special edition, carrying the latest results of the races.

This event heralds the first actual operation of a commercial air line from this city. The company recently was granted its papers of incorporation, and will maintain headquarters at the Ten Eyck, starting Monday.

The equipment consists of four planes, including two three-seater Travelair planes, powered by OX-5 Curtis motors, and capable of 110 miles an hour. Each accommodates two passengers and the pilot. These planes are of the latest passenger model, and are of the biplane type. A Pitcairn biplane and a Sikorsky monoplane, both new, commodious and safe, complete the flying equipment of the company. All are three-seaters.

Lieutenant Edward M. Pauley is head of the new corporation and Robert Aldrich is next in charge.

In addition to transporting the air mail edition of the Albany Evening News, passenger service to and from Saratoga Springs will be maintained. The planes will land on the state reservation, across the road from the New York state springs, and the papers will be transported the short distance from the field to the track by automobile.

Lieutenant Pauley, who will pilot the plane carrying the racing extra, said the trip will take about twenty minutes, depending on the weather and wind conditions.

"We selected Albany as our base because of the outstanding advantages it offers," Lieutenant Pauley said today. "We will give fast passenger, express and light freight service to any point. No hop will be too long.

"Other than transporting the editions of the Albany Evening News, we will not maintain any regular schedule for the present. The planes, as far as their number permits, will be available at all times, and we will welcome emergency flights.

"For the business man who needs to get to Syracuse or Buffalo or New York city in a hurry, our service is particularly directed. We aim to set no limit on our flying radius. If a man wants to fly to Chicago we will take him."

Lieutenant Edward M. Pauley and his plane.

Pauley headed a private company called Flyers, Incorporated, the first commercial air service based in Albany. With offices at the Ten Eyck Hotel, Flyers, Inc. carried passengers and freight and flew racing editions of the *Albany Evening News* to Saratoga Springs for the 1927 horse racing meet. Albany mayor John Boyd Thatcher mentioned Pauley's name as the future superintendent of the almost-constructed Albany Airport in Colonie.

Pauley told the *Evening News*, "We aim to set no limit on our flying radius. If a man wants to fly to Chicago, we will take him."

On Sunday, January 8, veteran pilot Raymond Henries flew from Long Island to Albany on his way to Buffalo, delivering a new Fairchild monoplane. The large single-engine plane was to be based in Buffalo for Colonial Western Airways. Henries had a passenger, former pilot George Benedict, who worked for his family's clothing business in Illinois.

Pauley decided to fly with Henries and Benedict to Buffalo, where two planes ordered by Flyers, Inc. were to be delivered. Pauley planned to make arrangements to have his new planes flown to Albany.

Despite thick fog, the Fairchild monoplane left Westerlo Island airfield south of Albany, piloted by Henries, around 2:00 p.m. Several hours later, Colonial Western Airways reported the aircraft had not reached Buffalo.

WGY radio in Schenectady, the cutting-edge electronic news medium of the day, broadcast that the plane was missing sometime after 6:00 p.m. Telephone reports poured in from listeners. Some heard what they thought was an airplane in distress about 3:00 p.m. near Rural Grove in the town of Root, on the south side of the Mohawk River between Fultonville and Canajoharie. A Mrs. Quackenbush of Rural Grove reported she heard a crash and was convinced the plane had fallen.

Early Monday morning, Sheriff Seeley Hodge formed a posse of about thirty men who began a ground search. Searchers found the wreckage on Tuesday morning near a farm being worked by J.E. Bartlett off what is today Route 162, between Currytown and Middle Grove. A plane from Schenectady Airport doing an aerial search for the downed aircraft saw the activity on the ground and landed on a nearby field.

Pilot Henries's body had been thrown about seventy-five feet from the main wreckage. The bodies of passengers Pauley and Benedict were found crushed inside the plane.

Opposite: News clipping describing how aviator Edward M. Pauley flew racing tip sheets from Albany to Saratoga in 1927. *Frances Burnham.*

The *Albany Evening News* reported, "Death rode on the wings of the wind with the three missing aviators whose bodies were found on a farm hillside near Rural Grove today, strewn with wreckage of their big Fairchild monoplane."

GAWKERS DESCEND

The crash investigation was hampered in the first few days by the arrival of what authorities estimated to be three thousand to eight thousand gawkers and souvenir hunters. Investigators could not find part of the instrument board of the plane. It was located in the possession of a Gloversville businessman.

The cause of the crash was never pinned down. The thick fog was likely a factor, but there were reports from people on the ground who heard a plane's engine overhead that seemed to be misfiring before the accident.

Captain Pauley was buried at Ferndale Cemetery in Johnstown. His story was researched by his great-niece, Frances N. Burnham of Scotia, with the assistance of town of Root historian Bill Maring.

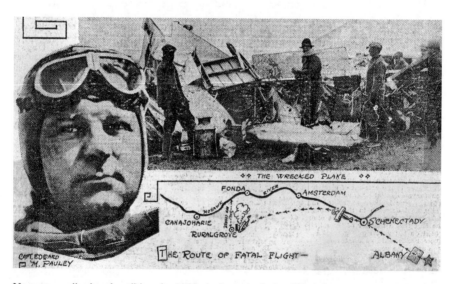

Newspaper clipping describing the 1928 airplane crash that killed three veteran aviators in the Montgomery County town of Root. *Frances Burnham.*

Chapter 37

The Jury Wanted Cigars

A night of drinking ended tragically in Amsterdam in 1913. James Major, twenty-two, was of French-Canadian ancestry and lived at 222 Forest Avenue. Major went out Wednesday, September 24, for a night of saloon hopping with Arthur Whitney, a fellow worker at the McCleary, Wallin & Crouse carpet mill.

Major was not married but had four brothers and two sisters. He enjoyed peaches. One of his relatives had brought a bushel of peaches home that September to can for James for the coming winter.

There were over eighty taverns in Amsterdam in 1913. Major and Whitney ended up at an establishment operated by James P. Mullarkey Jr., thirty-two, who had taken over the saloon at Church and Reid Streets from his father, James P. Mullarkey Sr. That corner is now occupied by a bank.

Major and Mullarkey Jr. got into an argument over a taxicab, and Mullarkey pushed Major away. The story in the Major family has been that Mullarkey hit Major over the head with a bottle. The district attorney tried to prove that Mullarkey punched Major, causing Major to fall, resulting in an ultimately fatal skull fracture. Mullarkey's defense argued that Major had fallen numerous times that night, and no one saw the alleged fatal blow.

After Major had fallen, he ended up lying outside the tavern. He was still alive and was seen in the early morning hours by two residents of the neighborhood's growing Polish community. When Mullarkey's father came early to open the tavern, Major's friend Whitney showed up. Whitney

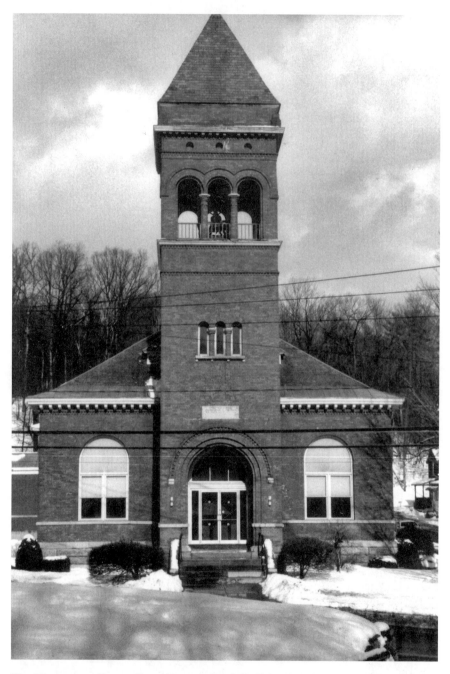

The Montgomery County Court House in Fonda, built in 1892. *Montgomery County Department of History and Archives.*

prevailed upon the elder Mullarkey to bring Major back inside, saying he did not want to take his friend home to his mother in his current state.

The people in the tavern believed Major was sleeping off the results of too much drink. They propped Major up in a back room chair, but he kept falling to the floor. Seeing that Major could not keep himself in the chair, the bartender put Major on the floor with an old coat for a pillow.

As the day went on, Major's need for medical attention became clear. Major's father arrived. When a doctor could not make it immediately to the tavern, a taxi was called, and Major was taken to his Forest Avenue home about 5:00 p.m. A doctor came to the home and declared Major gravely ill. Another taxi took the stricken man to St. Mary's Hospital at 7:00 p.m. He was pronounced dead five hours later.

Coroner Howard Murphy ruled that death came from bleeding in the brain, caused by a skull fracture, caused by violence. Major also had bruises on other parts of his body.

Police arrested Mullarkey, charging him with manslaughter. He was freed on bail, and the trial took place in March 1914 in Fonda.

The jury of twelve men deliberated for hours. They called for a dinner break and were taken to the Brunswick Hotel. That night they asked for cigars. At first the judge refused, but when they asked again, the judge ordered the men in the jury room be given cigars. Foreman John Voorhees told the judge on March 6 that jurors were deadlocked, six for conviction, six for acquittal.

The judge dismissed that jury, and the case went to trial again in October 1914. After forty minutes, the new jury found Mullarkey not guilty.

One of the victim's nephews and his namesake, James Major of Greenfield Center, said his father Alfred was fifteen when his brother died. The younger James Major reported he and his father once saw James Mullarkey in downtown Amsterdam in the 1940s. Alfred Major gave some thought to confronting the man acquitted in his brother's death but instead let the moment pass. Mullarkey died in Amsterdam in April 1957.

Chapter 38

The Singing Doctor

In 1889, a well-established Amsterdam physician sold his medical practice to another doctor and went to New York City to become a professional singer. Dr. John V. Riggs came back within two years, opened a drugstore on Market Street and eventually manufactured patent medicines.

Medicine and music dominated Riggs's life. The homeopathic physician had a strong bass voice. He founded and directed the Arion Society, an Amsterdam singing group. He was known for singing pieces called "Queen Esther" and "Belzhazzar's Feast" in performances at the Sanford Hall on West Main Street and the Union Hall on East Main Street.

Riggs was a member and one-time director of the St. Ann's Episcopal Church choir. Choir member and poet Emily Devendorf wrote rhymes describing her fellow choristers. Devendorf wrote of Riggs that "his voice is deep and tremendous strong, and without him, we do not so well get along."

A story about Riggs, written by his great-granddaughter, Anne DeGroff of Amsterdam, was judged the top entry in my Stories from the Mohawk Valley history essay contest in 2012.

DeGroff wrote the story in the form of a monologue spoken by Riggs at the end of his life, writing:

> *I was born in Schenectady in the spring of 1839. My father was a printer and publisher who, along with my grandfather, published the* Schenectady Cabinet [a local newspaper] *and that was not my calling whatsoever!*

After attending Princetown Academy and taking a course at Albany Medical College, I graduated from the Buffalo College of Physicians and Surgeons. But what I really wanted to do was sing and perform! So, after becoming a doctor, I managed to connect with the San Francisco minstrel troupe as an interlocutor and bass soloist and traveled with them.

While this troupe was performing in the south however, I left them to study yellow fever which was widespread at the time. I then returned to Amsterdam and began practicing medicine at 29 Market Street. Annie Wilds and I were married at St George's Church in Schenectady on October 31, 1861.

Annie Wilds Riggs died in 1909, and John died in 1917. The *Recorder* noted that Riggs provided the local paper with daily Amsterdam temperature statistics for twenty years. Husband and wife are buried at Fairview Cemetery.

The doctor died Thanksgiving eve, and Thanksgiving night, his son James S. Riggs carried on the family musical tradition. The younger

Riggs conducted the Liberty Bond Vocal Club at a concert that raised $150 to make life easier for Amsterdam soldiers who had been drafted into the U.S. Army.

The singing doctor, John Riggs. *Anne DeGroff.*

THE STORIES FROM THE MOHAWK VALLEY CONTEST

There were twenty-eight entries in the 2012 essay contest that was part of the promotional campaign for my history book, *Stories from the Mohawk Valley: the Painted Rocks, the Good Benedict Arnold and More.* There were cash prizes awarded, plus gift certificates to local stores. Each entrant received tickets to Amsterdam Mohawks baseball games played at historic Shuttleworth Park.

Anne DeGroff was especially pleased with praise she received in a note from her then eight-year-old grandson Darren, "Congrats on the award. 1st place, I'm blown away! I'm gonna read it tonight."

Theresa Moran of Glenville won second prize for the story of Blood & Howard, a broom factory in Fort Hunter. Ebenezer Howard and John D. Blood began the factory in 1859, one of the first in the country to make brooms from corn. Brooms were exported as far away as Australia. Blood sold out his interest to the Howard family in 1869. Fire destroyed the Fort Hunter factory in 1873, but it was rebuilt. When Ebenezer Howard died in 1891, he was described as "one of the influential residents of the Mohawk Valley."

Dave Northrup of Rochester, New York, was awarded third prize for his account of a downtown Amsterdam store. Grace Dechant of Scotia won fourth prize for her story of being stranded for two days on a Greyhound bus in Canajoharie during a blizzard in 1966.

Dechant said she was en route to Watertown for a student teaching assignment. "My memory of that first night includes standing in a long line to use the one available payphone, and then returning to the security of our bus for a fitful night."

Rounding out the top ten entries were: Peter Betz of Perth, who chronicled how Amsterdam entrepreneurs almost made the city a center for the airplane age but came down to earth in the stock crash of 1929; Cynthia DeGolyer of Johnstown, who recounted how her father, Victor DeGolyer, was Amsterdam's first draftee in World War II; Shawn Duffy of Lake St. Louis in Missouri, who wrote about his ancestor, tavern owner Martin O'Shaughnessy; John Naple of Amsterdam, who was a paperboy when he helped Sam Stratton get elected to his first term in Congress; Diane Smith of Amsterdam, who wrote about her grandfather; and Linda Ciulik Wisniewski of Doylestown in Pennsylvania, who told a story about one of her junior high school civics teachers. Several of these stories appear elsewhere in this book.

The stories were exceptional, and it was hard to pick the winners. I hope all the contestants will continue to write about our local heritage.

Chapter 39

Tragedy at the Laundry

A steam pipe that broke in the boiler room of an Amsterdam laundry more than sixty-five years ago claimed three lives, seriously injured another man and left Donald F. Lasher of Fort Johnson with indelible memories.

Lasher was a nineteen-year-old truck driver working for contractor Adam Haberek on the expansion of the Robison & Smith laundry on West Main Street in Amsterdam on Wednesday, October 8, 1947. A steam line with 250 pounds of pressure ran from a separate boiler room into the existing laundry.

On the scene that morning was one of the laundry's founders, Franklin Robison of Gloversville, who had started the business with Willard Smith decades earlier.

Lasher said that Robison asked the power shovel operator, Steve "Smitty" Kaufman, "to trim off the projections hanging from the end of the wall. Kaufman put the shovel under the wall, raised the whole wall off the ground and settled the wall down." Kaufman said he couldn't "get anything off." He removed the power shovel from the site.

Lasher said, "Mr. Haberek arrived to inspect the job. At that moment, Mr. Robison noted that dirt had crumbled from under the supporting wall. Steam was starting to leak from the flanged joint in the line outside the building."

Realizing the line would soon break, Robison sent boiler operator William Rule into the boiler room to shut down the system. Robison followed him. Another worker, DeMilt Quackenbush, and Lasher trailed behind.

Lasher said, "I stood by the side door and was wiping the closed door window to see the action outside when I suddenly found myself on the floor in a steam-filled room. When the wall fell, the pipe had broken outside. It swung down inside with the open end three feet from the floor. Five inches of 250 pound steam was escaping into the room."

Lasher continued, "I realize now the good Lord was with me for before me was light. I crawled through the door that was letting in the light. It had blown open enough for me to get through. I escaped without a scratch."

Lasher ran to the back entrance. Quackenbush, fifty-one from Fort Hunter, tried desperately to get out, but the green swinging doors opened inward.

"An arm came crashing through the window, extended slowly and slid back into the building never to be seen again," Lasher said.

Lasher's truck was nearby. He started the truck and forced the doors open with the truck's bumper. He parked the truck and ran back to the side entrance.

Lasher said, "Quackenbush made it to the back of the room but not out. Mr. Robison wandered around in the room, trying to shut off the boilers. Like the walking dead, he came out." Robison, sixty-two, died two days later.

Rule, the boiler man who lived at 188 Division Street in Amsterdam, came out and could not speak. Lasher's wife, Helen, later told her husband that Rule's adrenaline brought him out of the building. He died later that day.

The boilers were turned off although steam was still escaping as screaming sirens announced the arrival of firemen. Quackenbush was dead when firemen found him inside. A coroner's inquest later ruled the deaths of Quackenbush, Robison and Rule accidental.

Haberek was rescued, coming out supported on either side by firemen. Lasher said, "He had found refuge in the runoff ditches along the walls of the boiler room where he had crouched in a fetal position. His burns were limited to whatever skin had been exposed."

Several days after the accident, the attending physician, Dr. E.A. Bogdan, told the *Recorder* that Haberek was able to sit up in a chair for a short time. He was told of the deaths of his three companions, which had been withheld from him, though he had been prepared for the shock through the statement that there was no hope for them.

Bogdan said Haberek's throat was scalded by swallowing or breathing in the steam, but he was able to eat. Lasher said Haberek didn't totally recover for at least a year, when he went back to work.

"I escaped," Lasher said, "because I saw the light to clear outside air. Thank you, God Almighty."

Chapter 40

Maria Riccio Bryce and the Amsterdam Oratorio

When performed in October 2001 over several nights at Lynch Middle School, the Amsterdam Oratorio played to packed houses. About seventy people from the community worked on the ninety-minute production.

An oratorio is a musical work that tells a story through songs performed by a chorus and soloists. The Amsterdam Oratorio featured songs about immigrants, mills, teachers, nurses, firefighters, soldiers, priests, families and sports, plus a tribute to local native Kirk Douglas and an ode to a vanished downtown.

"Amsterdam felt so alive then," wrote composer Maria Riccio Bryce, saying that the old downtown was a "backdrop for life" where "the laughing, the free and the broken-hearted made their own way down Main Street." Veteran performer Matthew Cinquanti gave a show-stopping rendition of Bryce's "Elegy for Downtown."

The names of the stores bring back memories: Bargain City, Community Pharmacy, Olender's, Larrabee's Hardware, Card-O-Rama, Mortan's, Gabays, Seely Conover, Wagenheim's Furs, Furs by Gus, Whelan's Drugs, the Enterprise Store, Hallett's and Holzheimer & Shaul.

Baby boomers remember crowding into booths at Wilson's Drugstore as teenagers. The latest hit song played over and over on the loudspeaker outside Dangler's Music Store. Main Street on Friday night was filled with boys cruising and girls flirting.

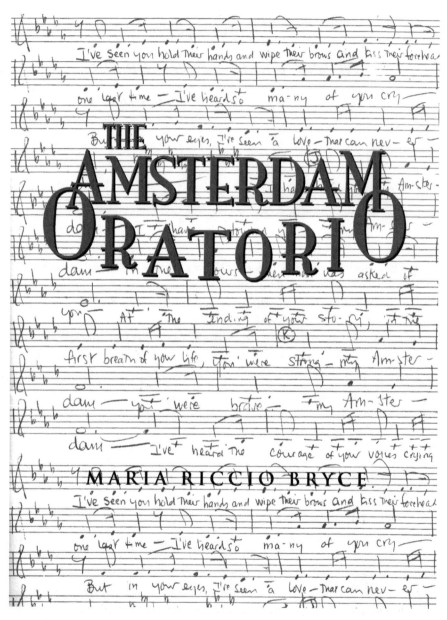

Amsterdam Oratorio program from 2001. *Author's collection.*

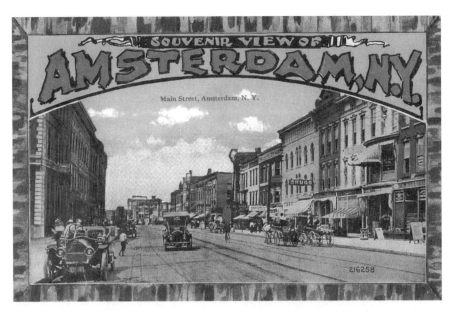

A souvenir view of Amsterdam's East Main Street from the early 1900s, looking west from Church Street. *Montgomery County Department of History and Archives.*

A similar view of East Main Street in downtown Amsterdam in 2012 during the annual Spring Fling festival. *Gerald Skrocki.*

DON'T FORGET ME, AMSTERDAM

Riccio Bryce does not plan to perform the Oratorio live again. "It was written for a specific moment, for specific performers," Bryce said, adding she does not think she can replicate the experience.

If one piece symbolizes the Oratorio it is "Requiem," a tribute to fallen soldiers, performed by Bryce's youngest son Peter, who was a Harvard College student in 2001. Peter went on to study law.

Bryce was inspired to write Requiem by the 1967 death of Marine Captain Lawrence Celmer in Vietnam. Bryce's father made her go to Celmer's wake when she was a teen. Celmer looked like he was sleeping, a phrase used in "Requiem." Celmer was the only child of former Amsterdam police chief Andrew Celmer and his wife, Valeria.

Amsterdam attorney Robert Going has posted a recording of Requiem on Youtube, along with pictures from his book *Honor Roll: the World War II Dead of Amsterdam, N.Y.* The site has had over one thousand visitors. Requiem is frequently played at services in Amsterdam honoring soldiers on Memorial Day or Veterans Day.

A professionally recorded compact disc of the Amsterdam Oratorio was underwritten by movie star Kirk Douglas. There is also a videotape of one of the performances that Bryce would like to see transferred to a digital format.

A MUSICAL LIFE

An Amsterdam native, Bryce began piano lessons at age nine. She accompanied others on the piano and also acted in high school plays, directed by drama coach and later high school principal Bert DeRose.

In 1968, she won the high school's Kirk Douglas Award for her role in *West Side Story*. Douglas, a childhood friend of Bryce's late father Peter Riccio, wrote her a letter of congratulations. Her father was the person who convinced Douglas to go to St. Lawrence University.

In the Oratorio, Bryce said, "Kirk Douglas is a metaphor for all the kids from Amsterdam who went on to other things and places." John Allen portrayed Douglas

Bryce herself left Amsterdam for a career in theater. After graduating from Manhattanville College, she married an Englishman, and together they founded a leading "fringe" theater in London in the 1970s. When

arts subsidies dwindled in England, the Bryces returned to Amsterdam in 1982.

Before creating the Oratorio, Bryce composed and produced the Schenectady musical *Hearts of Fire* in 1991. She also created the musical *Mother I'm Here* in 1988, a tribute to her mother. Alberta Thomas Riccio died in 2007.

The idea for the Oratorio came to Bryce at a low point in her life. In 2000, she was trying to rebound from divorcing her husband and faced the prospect of an empty house as the youngest of her three sons went off to college.

She saw an ad for a grant program for a community artwork. Bryce said she has always needed a commission to get her motivated. "I felt a divine hand," Bryce said.

She almost immediately envisioned the songs that would become the Oratorio and many of the people who would sing them. Bryce was particularly pleased to find fifteen-year-old Amy Melendez to sing the song about the Latino experience, "Don't Say You Don't Know." Melendez today is the mother of twin girls—and still sings.

The Oratorio was nearing its debut in 2001 when terrorists attacked America on September 11. Bryce's first thought was to cancel the production. But a fellow musician convinced her that the show should go on. "I was crying and carrying on, and I said to him, I felt God was with me as I wrote this work and I didn't know, when I was writing, what was going to happen to our country.

"And my friend said, 'Maria, He knew.' As you know, we went on with the show."

Chapter 41

An Engineer with a Love of History

C. Robb DeGraff of Amsterdam supervised construction of the 1930 Batchellerville Bridge over the Sacandaga Reservoir. DeGraff's bridge over what is now known as Great Sacandaga Lake was replaced by a new, higher span on November 15, 2012. The original bridge, over eighty years old, was torn down.

In 1956, DeGraff drew a detailed map of the area flooded for the reservoir with numerous historical references. His map focuses on Fish House.

"Fish House was an old stamping ground of mine," DeGraff told the *Recorder*. "I had relatives who used to operate a country store in that vicinity."

Fish House got its name because Colonial leader Sir William Johnson had built a path in 1762 from his estate in Johnstown to a good fishing spot on the Sacandaga River.

In January 1894, Fish House was the scene of a murder. DeGraff said, "The feud by hotel owners Walter Brown and 'Hi' Osborne resulted in the murder of Osborne by Brown. The Osborne Hotel burned in 1895."

Fish House had a covered bridge over the Sacandaga River built in 1818 that was destroyed by the 1930 flooding that created the reservoir. Half of Fish House was flooded. Fish House residents had wanted the 1930 bridge built in their area, but officials chose Batchellerville instead. DeGraff said people in Fish House were never really satisfied with the reservoir construction.

An Engineer's Life

A native of Utica, DeGraff was born in 1882. His family moved to Amsterdam, and he graduated from Amsterdam High School, and then studied civil engineering at New York University. After college, he worked for the Schenectady Railway Company on trolley lines connecting Schenectady with Troy and Ballston Spa.

In 1905, he began almost twenty years of service with the New York State Engineering Department. He was engineer in charge of highway and Mohawk River/Barge Canal projects, including construction of canal lock bridges in Canajoharie, Amsterdam, Cranesville and Rexford. He married Eloise Milmine of Amsterdam in 1916. They had two children.

In 1923, DeGraff left civil engineering for several years and became an official of a textile plant in Fall River, Massachusetts.

When the Sacandaga Reservoir was created in 1930, DeGraff was appointed resident engineer for the Hudson River Regulating District to supervise construction of Batchellerville Bridge.

He was commissioner of public works for the city of Amsterdam during the administration of Republican mayor Robert Brumagin in the early 1930s. In the late 1930s, DeGraff became area director for New Deal Works Progress Administration public projects in seven counties with his headquarters in Utica. In the 1940s, he was district engineer for the New York State health department.

Amsterdam Bypass

One of DeGraff's last acts of public service was to put forward an alternative to the highway plan proposed for Amsterdam after construction of the New York State Thruway. In 1957, DeGraff sketched a proposed arterial highway that would have put a new bridge over the Mohawk River east of Amsterdam near Widow Susan Road. Route 30 traffic would use that road to bypass the city.

DeGraff outlined his proposal during a Rotary Club speech, and historian Hugh Donlon noted that a "considerable number" supported DeGraff's bypass proposal. Donlon wrote that people were starting to realize "that arterials passing through the core of the city would necessitate drastic community surgery."

In a newspaper article, DeGraff said that his proposal may have defects, but it would not cause the "congestion, expense and inconvenience" of building a new Route 30 through Amsterdam.

DeGraff died in 1958. The highway plan that ultimately prevailed ignored DeGraff's idea and sent Route 30 traffic through the center of Amsterdam.

Chapter 42

Skipping School for JFK

Presidential candidate John F. Kennedy drew a crowd of three thousand to a parking lot on Grove Street in downtown Amsterdam on Thursday, September 29, 1960.

My friend Paul Russo and I skipped school to get there, simply going out the door of Wilbur H. Lynch High School on Brandt Place and walking several blocks to Grove Street. We were sophomores.

Russo, now a retired science teacher in Johnstown, recalled that after the speech, he got close enough to shake hands with the future president. A *Recorder* picture showed Amsterdam police sergeant Peter Torsiello leading Kennedy through a throng of hand shakers.

Afterward, we were chided by our Latin teacher, Marion Cline, when we showed up late for afternoon class. We were not disciplined.

Kennedy and a bevy of prominent Democrats, including former governor Averill Harriman and Congressman Sam Stratton, arrived a bit before noon and left Amsterdam in short order for a campaign stop in Canajoharie.

In Amsterdam, Kennedy advocated a $1.25 hourly minimum wage and said responsibility for rebuilding the economy of depressed cities lay partly with the community and partly with the state and nation.

Teacher Overruled

Linda Ciulik Wisniewski was an Amsterdam junior high student at the time. She said her teacher's effort to get her class to witness Kennedy's visit was overruled as too political by Principal John McKnight.

Wisniewski said:

> *I see her still, standing before our civics class, tall and slim in a tailored suit. In ninth grade, I thought she was very smart and often funny. When she strode down the halls of Theodore Roosevelt Junior High, her stacked heels made a loud noise on the wooden floor.*
>
> *Our school had no computers, no air-conditioning and no women wearing pants. I would not hear about women's liberation for years, but Mrs. Arlene Brown was about to teach me something about standing up for yourself.*
>
> *On that sunny September morning, I was fourteen years old. I never raised my hand or spoke in class. In church, I sat in the pew like a porcelain statue. I was especially afraid of doing or saying the wrong thing, so I did not move or speak.*
>
> *Mrs. Brown's voice was always loud, but that day in her civics class, it shook and had a higher pitch. Tears shone in her large brown eyes.*

Wisniewski said Brown told the class she had promised the principal that if Richard Nixon, Kennedy's opponent, came to Amsterdam, she would take her students to see him as well. But the principal did not approve that idea either.

Wisniewski said:

> *The class fell silent, shocked that she stood up to her boss. For me, however, it was much more. For the first time, I saw a strong woman cry angry tears, and my world opened up like a flower. My teacher refused to be an acquiescent female or to sugarcoat the truth.*
>
> *On that autumn day in 1960, Mrs. Brown didn't get what she wanted, and I have no idea how this affected her job, but sometimes good things grow from disappointment. Watching her, I found my voice.*
>
> *It has never been easy for me to speak through tears, but when I do, I like to remember her, standing tall, filling my head with possibilities.*

Richard Nixon did not visit Amsterdam in 1960 but did campaign in Schenectady. Kennedy carried Montgomery County with 15,976 votes over Nixon's 14,837.

McKnight retired as principal of the junior high in 1972 and passed away in 1993. At some point, Brown became a teacher in Schenectady, according to Wisniewski. Wisniewski submitted her essay as part of my Stories from the Mohawk Valley contest. She is a writer and lives in Doylestown, Pennsylvania.

Chapter 43

Floods Along the Mohawk

Tropical Storms Irene and Lee wreaked havoc in the Mohawk and Schoharie Valleys in late August and early September of 2011. Local historic sites were not spared.

WALTER ELWOOD MUSEUM

Historic Guy Park Manor at Lock 11 on the Erie Canal/Mohawk River in Amsterdam suffered tremendous damage during Tropical Storm Irene. At the time, the Walter Elwood Museum was located in the building. Work continues at last report on repairing the manor, the 1774 home of Guy Johnson, nephew of Sir William Johnson, British superintendent of Indian Affairs.

The Elwood, the region's local history museum, is not returning to Guy Park Manor. The future of the manor is not clear, but there has been talk of it becoming the headquarters of the New York State Canal Corporation once the building is restored by the state.

In February 2013, the Elwood Museum purchased five parcels, 96,000 square feet of space, in former factory buildings at 100 Church Street in Amsterdam, near city hall. The buildings were most recently owned by the Constantino family's Noteworthy Corporation, a manufacturer of plastic litterbags and other promotional products. Previously the buildings were part of the Bigelow-Sanford carpet mills.

Museum director Ann Peconie said the move to Church Street is being made possible by contributions from members of the community. Items rescued from Guy Park Manor have been stored at the Fucillo Jeep dealership on Division Street.

The museum was originally created by Amsterdam schoolteacher Walter Elwood from his own collections gathered from around the world. The museum today has about twenty-five thousand artifacts in four categories: multicultural, Victorian, natural history and items relating to the region's industrial past.

Old Fort Johnson

Old Fort Johnson is the 1749 fortified limestone house on the north bank of the Mohawk River built by Sir William Johnson. The Old Fort was flooded by both Tropical Storms Irene and Lee. After a tremendous amount of cleanup work, there was a shortened season in 2012. The Old Fort, owned by the Montgomery County Historical Society, opened in May 2013 for a full season of activities.

Curator Alessa Wylie said the fort and visitor's center have been fully restored.

Artifacts and exhibits, moved out of harm's way before the flood, are back in place. The eighteenth-century privy, almost swept away in the flooding, is being restored. The gardens are improving and look as good, if not maybe a little better, than before the flood.

Visitors who are not from the area look at our flood pictures with amazement, not quite believing that we have recovered so quickly. We feel the same way and know that we could not have done it without all the people who so generously gave their money, time and expertise during our recovery. Thanks to all who helped. We're so glad to be back.

Schoharie Crossing

Schoharie Crossing State Historic Site is at the confluence of the Schoharie Creek and Mohawk River in the hamlet of Fort Hunter, not a safe place to be during the 2011 tropical storms. In fact, the one Montgomery County

fatality in the aftermath of Tropical Storm Irene took place in that area when raging waters of the Schoharie Creek swept away a pickup truck driven by seventy-two-year-old Stephen Terleckey of Karen's Produce on Route 5-S in nearby Auriesville.

The floods washed the Schoharie Crossing parking lot away, damaged the visitor's center and destroyed interpretive signs. The historic site was previously focused on the history of the aqueduct that carried the Erie Canal over the Schoharie Creek in the 1800s. But the flooding uncovered the site of the colonial Fort Hunter in the footprint of what had been the parking lot. An archaeological dig has discovered new information about the British fort, built in 1712. The fort also housed Queen Anne's Chapel, described in an earlier chapter of this book, Queen Anne and St. Ann's.

Schoharie Crossing has since reopened, with new exhibits interpreting the archaeological excavation of Fort Hunter. New signage, new visitor parking and pathways and a new playground are all being installed in the wake of the storms.

How High the Water

Even though high water has always been a fact of life along the Mohawk River and its tributaries, serious floods appear to have increased in frequency in recent years.

In late June 2013, there were destructive flash floods along the Mohawk during a period of heavy rain. Fort Plain, Little Falls, Herkimer, Mohawk in Herkimer County and surrounding villages bore the brunt of the damage.

Eighty-six-year-old Edith Healey of Fort Plain died when her mobile home was carried away by waters of the Otsquago Creek, which rose dramatically. Her body was found in debris that collected at Lock 14 of the Mohawk River/Erie Canal.

A U.S. Geological Survey official estimated the height of the Otsquago Creek in Fort Plain in the 2013 flood was seven feet higher than its previously recorded high mark. Otsquago Creek begins as a rivulet north of Summit Lake in Otsego County. The creek falls 1,100 feet over its seventeen-mile length before entering the Mohawk River.

A flood in 2006 did great damage in Canajoharie, Fort Plain, Fonda, Fultonville and other locations. The flood of 1996 in Fonda helped convince officials to relocate the county jail from its previous location near the river in Fonda to its present spot on higher ground in Glen.

The Schoharie Creek can be dangerous. In 1987, raging waters took down the Thruway Bridge over the Schoharie, claiming ten lives. Fort Plain's Otsquago Creek previously flooded in 1981, destroying the historic limestone aqueduct that carried the Erie Canal over the creek.

The spring of 1958 brought major flooding along the Mohawk River. After that event, the Army Corps of Engineers built retaining walls along the south side of the river in Amsterdam.

The Mohawk Valley was hard hit by a flood in February 1938. A carpet mill on the riverbank in Amsterdam fell into the swollen river, battered by ice floes. Amsterdam's gas supply was cut off because water surrounded the gashouse, near what is now Riverlink Park.

Bert DeRose, who was six years old at the time, said his uncles worked for the city and were assigned to bridge duty. "Sure enough, the river began to run over its bank. I remember my uncle running to inform us that we had to leave right away."

DeRose said when the river finally receded, it left large chunks of ice in the family's backyard. "Needless to say, a six-year-old boy spent many a day playing on those chunks of ice."

An early March flood in 1913 washed out the bridge at Canajoharie. Amsterdam's Mohawk River Bridge was taken out by high water on March 27, 1913. The temporary bridge that replaced the fallen span was itself demolished by a flood one year to the day later. March 27 became known as Bridge Day in Amsterdam.

A flood in March 1910 disabled railroad service from Fonda through Herkimer for two days. A violent downpour lasted for twenty-six hours in the Mohawk Valley in October 1903. Streets and trolley lines were washed out in Amsterdam, and the trolley system's powerhouse was flooded in Tribes Hill.

Bibliography

Barrows, Nat A. *Blow All Ballast!* New York: Dodd, Mead & Co., 1950.

Beers, Frederick W. *History of Montgomery and Fulton Counties.* New York: F.W. Beers & Co., 1878.

Cudmore, Bob. *Stories from the Mohawk Valley: the Painted Rocks, the Good Benedict Arnold and More.* Charleston, SC: The History Press, 2011.

———. *You Can't Go Wrong: Stories from Nero, New York and Other Tales.* Glenville, NY: Nero Publishing, 2000.

Dauria, Susan R. "Deindustrialization and the Construction of History and Ethnic Identity: The Case of Amsterdam, New York." University at Albany doctoral thesis, 1999.

Donlon, Hugh P. *Annals of a Mill Town: Amsterdam, New York.* Schenectady, NY: Donlon Associates, 1980.

———. *Outlines of History: Montgomery County.* Amsterdam, NY: Noteworthy Corp., 1973.

Douglas, Kirk. *The Ragman's Son: An Autobiography.* New York: Simon and Schuster, 1988.

Farquhar, Kelly Yacobucci. *Images of America: Montgomery County.* Charleston, SC: Arcadia, 2004.

Farquhar, Kelly Yacobucci, and Scott G. Haefner. *Images of America: Amsterdam.* Charleston, SC: Arcadia, 2006.

Going, Robert N. *Honor Roll: The World War II Dead of Amsterdam, N.Y.* Amsterdam, NY: George Street Press, 2010.

————. *Where Do We Find Such Men?* Amsterdam, NY: George Street Press, 2013.

Golab, Adam. *The Mighty and Awesome Chuctanunda Creeks Runs Through a Limestone City*. Amsterdam, NY: Self-published, 1999.

Greene, Nelson. *History of the Mohawk Valley: Gateway to the West, 1614–1925*. Chicago: S.J. Clarke Publishing Co., 1925.

Hildebrandt, Louis. *Riders Up*. Glens Falls: Sierra Solutions ADK, 2003.

Hildebrandt, Louis M., Jr. *Hurricana: Thoroughbred Dynasty, Amsterdam Landmark*. Troy, NY: Troy Bookmakers, 2009.

Huey, Lois M., and Bonnie Pulis. *Molly Brant: A Legacy of Her Own*. Youngstown, NY: Old Fort Niagara Association, 1997.

Keesler, Paul M. *Mohawk: Discovering the Valley of the Crystals*. Utica, NY: North Country Books, 2009.

Larner, Paul K. *Our Railroad: The History of the Fonda, Johnstown & Gloversville Railroad (1867–1893)*. Bloomington, IN: Author House, 2009.

McMartin, Barbara, and W. Alec Reid. *The Glove Cities: How a People and Their Craft Built Two Cities*. Caroga, NY: Lakeview Press, 1999.

Murphy, Jacqueline Daly. *St. Mary's Parish: A History*. Amsterdam, NY: St. Mary's Church, 2004.

Northrup, Dave. *The Memory of Broken Things and Other Stories of Amsterdam and the Mohawk Valley*. Rochester, NY: Mountain Air Books, 2012.

Pacelli, Tony. *Past and Present: Nostalgia, Amsterdam and Sounding Communities*. Amsterdam, NY: The Recorder, 1987.

Pietrusza, David. *Baseball's Canadian-American League*. N.p.: McFarland & Co., 2005.

Reid, W. Max. *The Mohawk Valley: Its Legends and Its History*. New York: G.P. Putnam and Knickerbocker Press, 1901.

Robb, Alex M. *The Sanfords of Amsterdam*. New York: William-Frederick Press, 1969.

Snyder, Gerald R., and Robert von Hasseln. *Amsterdam* (Postcard History Series). Charleston, SC: Arcadia, 2010.

Strobeck, Katherine M. *Mohawk Valley Happenings*. Fort Johnson, NY: Montgomery County Historical Society, 1990.

————. *Port Jackson: An Erie Canal Village*. Amsterdam, NY: Port Jackson Publishing Co., 1989.

Towne, Jay. *Shhh! This Is God's House: Interviews with Religious Leaders in the Mohawk Valley, NY*. N.p.: 2013

Tralka, George A. *Diary of a Replacement Soldier*. N.p.: Xlibris, 2011.

Weaver, Dan, ed. *Upstream Three: A Mohawk Valley Review*. N.p.: Amsterdam, N.Y., 2013.

ONLINE INFORMATION

Tom Tryniski maintains a database of many newspapers in New York State: http://www.fultonhistory.com/Fulton.html.

Frank Yunker maintains a database with many of Bob Cudmore's *Daily Gazette* columns, plus other information: www.mohawkvalleyweb.com.

DOCUMENTARIES

Bannon, Colin. *True Stories from Rug City*. Syracuse University, 2007.

Dunn, Steve, and Bob Cudmore. *Historic Views of the Carpet City: Amsterdam, N.Y.* WMHT, 2000.

Durfee, Joanne. *Our Town Amsterdam*. WMHT, 2010. www.wmht.org.

Rombout, Rob, and Rogier van Eck. *Amsterdam Stories USA*. Belgian Cultural Board, 2013.

About the Author

B ob Cudmore has written a weekly newspaper column on Mohawk Valley history for the *Daily Gazette* for over a dozen years. He is the author of *Stories from the Mohawk Valley*, published in 2011 by The History Press. Cudmore published the book *You Can't Go Wrong*, a satirical look at Upstate life in 2000. That same year, he and Steve Dunn co-produced a WMHT-TV documentary about Amsterdam history, *Carpet City*.

Roser Communications Network.

A radio and television personality, Cudmore began hosting the morning show on Lite 104.7/1570 AM WVTL radio in Amsterdam in 2004. From 1980 to 1993, he hosted the nightly *Contact* talk show on WGY radio in Albany.

A former adjunct instructor in mass media at Albany's College of St. Rose, Cudmore worked in public relations for the State University of New York from 1993 to 2001. He has an MA and BA in English from Boston University. A native of Amsterdam, Cudmore lives in Glenville with his sweetie, Audrey Sears, and has two children: Bob Cudmore Jr. and his companion, Tamar Sarnoff of Baltimore, Maryland; and Kathleen R. Bokan and her husband, Michael Bokan of West Charlton, New York.